THE MALE AND FEMALE FIGURE IN MOTION

60 CLASSIC PHOTOGRAPHIC SEQUENCES

EADWEARD MUYBRIDGE

DOVER PUBLICATIONS, INC.
NEW YORK

Published in Canada by General Publishing Company, Ltd., 30 Lesmill Road, Don Mills, Toronto, Ontario.

This Dover edition, first published in 1984, is a selection of 60 sequences from the eleven-volume work *Animal Locomotion: an electro-photographic investigation of consecutive phases of animal movements*, originally published under the auspices of the University of Pennsylvania, Philadelphia, in 1887. A publisher's note, captions and list of plates have been prepared especially for this edition. The publisher's note draws heavily upon Anita Ventura Mozley's introduction to the Dover edition of the complete work, entitled *Muybridge's Complete Human and Animal Locomotion* (three vols.: 23792-3; 23793-1; 23794-X).

DOVER *Pictorial Archive* SERIES

Manufactured in the United States of America
Dover Publications, Inc., 31 East 2nd Street, Mineola, N.Y. 11501

Library of Congress Cataloging in Publication Data

Muybridge, Eadweard, 1830–1904.
 The male and female figure in motion.

 1. Human locomotion—Pictorial works. I. Title.
QP301.M86 1984 612'.76 84-6060
ISBN 0-486-24745-7

Publisher's Note

Edward James Muggeridge was born on April 9, 1830 in Kingston-upon-Thames, England. He made several alterations to his name, finally settling on Eadweard Muybridge. He emigrated to the United States and in the 1850s established himself in the book trade in San Francisco. In 1860 he sustained a serious head injury in a stagecoach accident; some think this contributed to his eccentric nature. Recovering in England, he was introduced to the art of photography, in which he soon became completely absorbed.

Muybridge returned to San Francisco in 1867 and quickly established himself as a leading photographer by producing a spectacular series of views of the Yosemite Valley. The government recognized his abilities; in 1868 he accompanied an expedition to examine the newly acquired Alaskan territories. He also produced views of the lighthouses on the Pacific Coast for the United States Lighthouse Board.

Leland Stanford, a former governor of California and the president of the Central Pacific Railroad, took note of the photographer in 1872 and decided that he was the man to help him find the solution to a vexing problem. Stanford bred horses and raced trotters. He held (correctly, but without proof) that, at some point during a fast trot, a horse will have all four legs off the ground simultaneously. Stanford turned to Muybridge to provide photographic evidence to support his supposition. Muybridge was intrigued by the challenge (for up to that time no photographs had been taken at the speed necessary to capture such action) and was beginning to develop a method for approaching the problem when a personal tragedy almost ended his career.

In 1874 Muybridge discovered that the son borne him by his younger wife was, in fact, not his. Having determined that the father was one Harry Larkyns, he sought the man out and shot him to death. Muybridge came close to being lynched. At his trial in 1875, a plea of insanity was entered but the jury ignored it, choosing instead to acquit Muybridge on the ground that Larkyns had deserved his fate.

Soon after the trial, Muybridge spent six months photographing various sites in Panama and Guatemala. Returning to San Francisco, he made a successful panorama of the city and environs and then, once again, directed his attention to the movement of the horse. Resuming his collaboration with Stanford, he developed chemical and mechanical techniques to capture motion in sequences. The publication of his results allowed people, for the first time, to see clearly attitudes taken by horses in motion.

Muybridge found that public curiosity was sufficient to warrant lectures on his experiments. To illustrate them he developed the zoopraxiscope, which, using the principle of the zoetrope, allowed him to project images creating the appearance of motion. On the basis of this invention, many people credit Muybridge as the inventor of the motion picture.

In August 1881 Muybridge went to Europe, where he was greeted with enthusiasm. On November 26 the painter Ernest Meissonier held a glittering reception for him in Paris. Initially, Muybridge met with similar acclaim when he went to England, counting among his audiences Gladstone, Tennyson, Huxley and the Prince and Princess of Wales.

On his return to the United States in 1882, Muybridge continued to lecture, but also turned his attention toward organizing a project to further his investigations into locomotion by photographing men, women, children and animals, using a setup much like the one he had developed with Stanford. Unable to finance the project himself, he finally arranged for it to be done under the auspices of the University of Pennsylvania. In return for the facilities provided, Muybridge agreed to work under the supervision of members of the university representing the worlds of science and art, including the great painter Thomas Eakins.

Work began in 1884; the last series that was included in the final work was photographed on October 28, 1885. The university published *Animal Locomotion; an electro-photographic investigation of consecutive phases of animal movements* in eleven volumes in 1887. Subscribers paying $100 were entitled to order 100 plates from the total of 781. To drum up business, Muybridge continued his lecture tours in the United States and Europe. In the end, close to 450 copies were sold.

After running an exhibition of the zoopraxiscope on the Midway of the World's Columbian Exposition of 1893, Muybridge returned to England permanently. He died in Kingston-upon-Thames in 1904.

The 60 sequences presented in this volume were selected from the complete set of 781. To understand the plates fully it is necessary to discuss Muybridge's method briefly. In an open shed about 120 feet long a background, against which the models moved, was marked off by threads into squares of 5 cm (approximately 2 inches). These aided in following the movements and facilitated use by artists. Parallel to the shed was a fixed battery of 24 cameras. Two portable batteries of 12 cameras each were positioned at both ends of the shed, either at an angle of 90° relative to the shed or at an angle of 60°. The equipment (and the use of newly available gelatin dry plates) allowed three photographs to be taken simultaneously, one from each battery. The photographs reproduced in the plates (frequently featuring views from all three vantage points) are numbered in chronological order, going from left to right if such was the principal direction of the action being recorded; right to left if the motion occurred in that direction. When several separate sequences are recorded on a plate, they are differentiated by letter. The descriptions of the activities depicted are based closely on those assigned by Muybridge in his *Prospectus and Catalogue of Plates*. The sequences are arranged as follows: men nude, men in pelvis cloth, women nude, women partially draped, children.

Contents

MEN

WOMEN

CHILDREN

THE MALE AND FEMALE FIGURE IN MOTION

60 CLASSIC PHOTOGRAPHIC
SEQUENCES

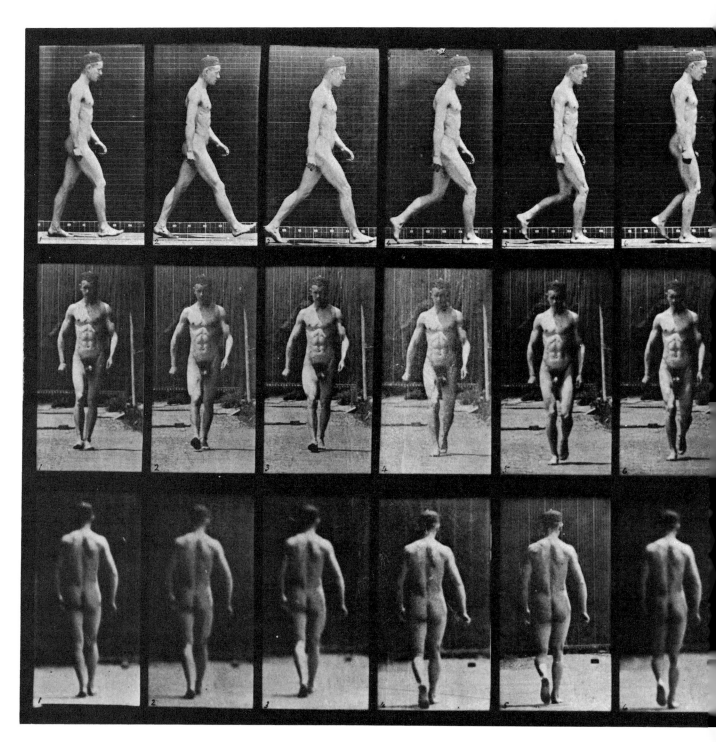

1. Walking.

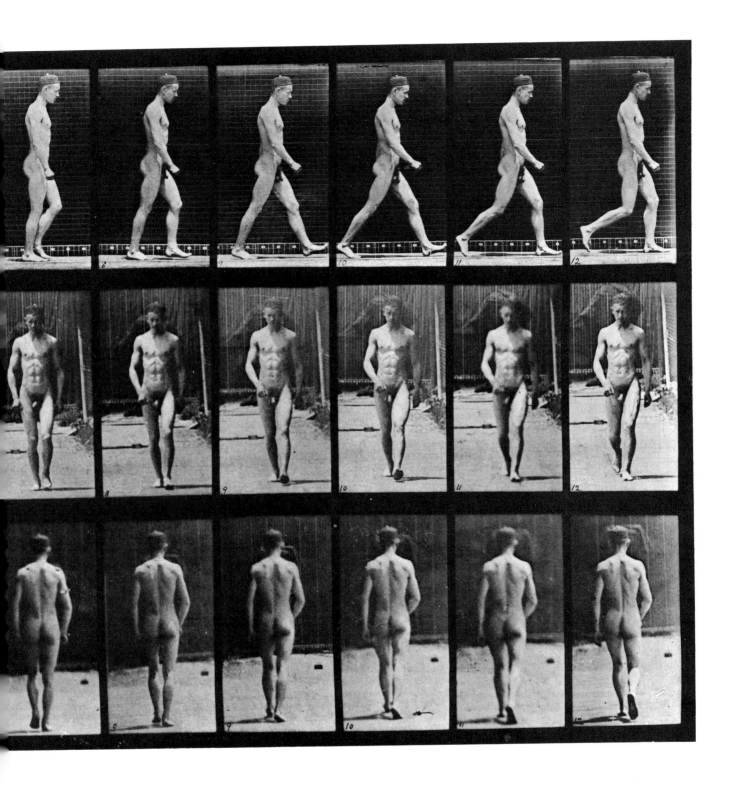

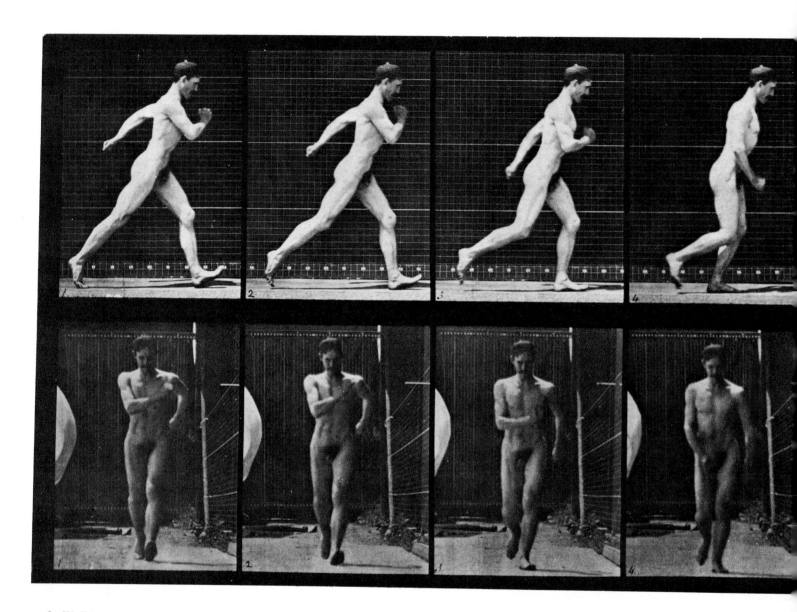

2. Walking.

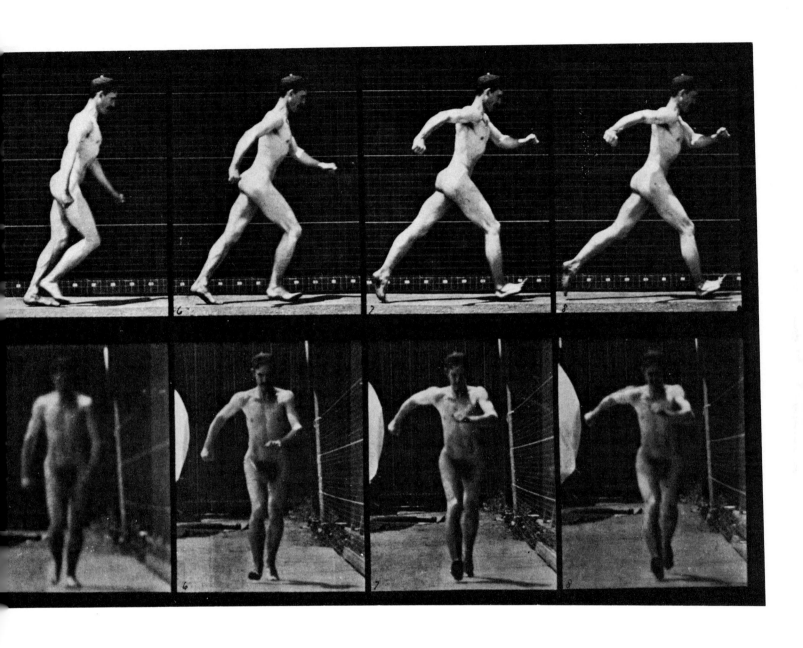

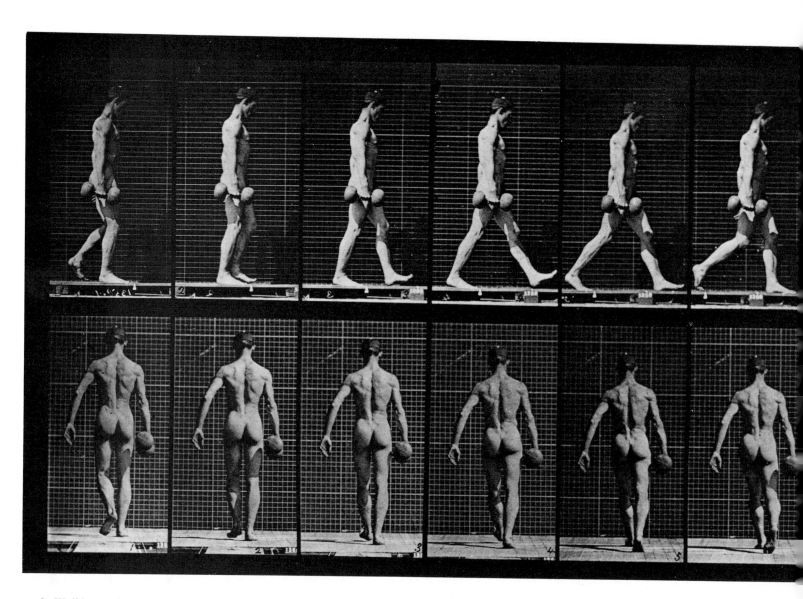

3. Walking and carrying a 50-lb. dumbbell in right hand.

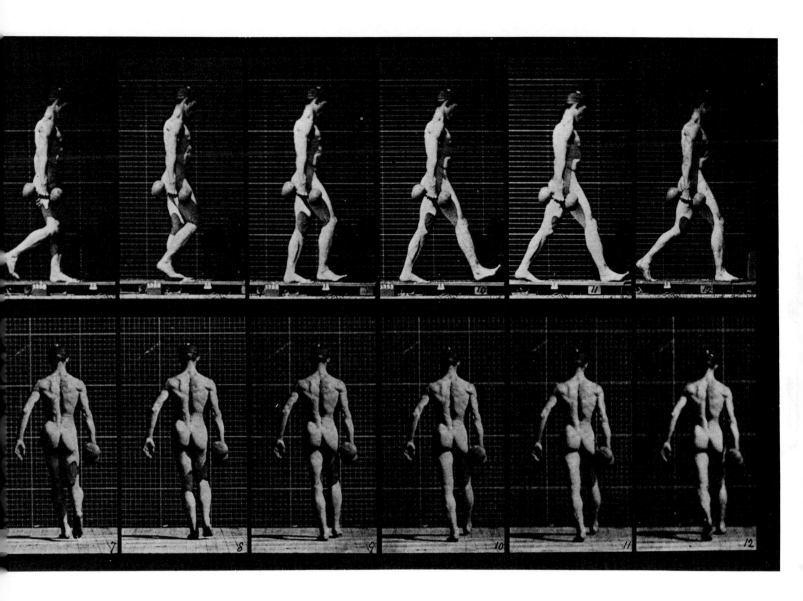

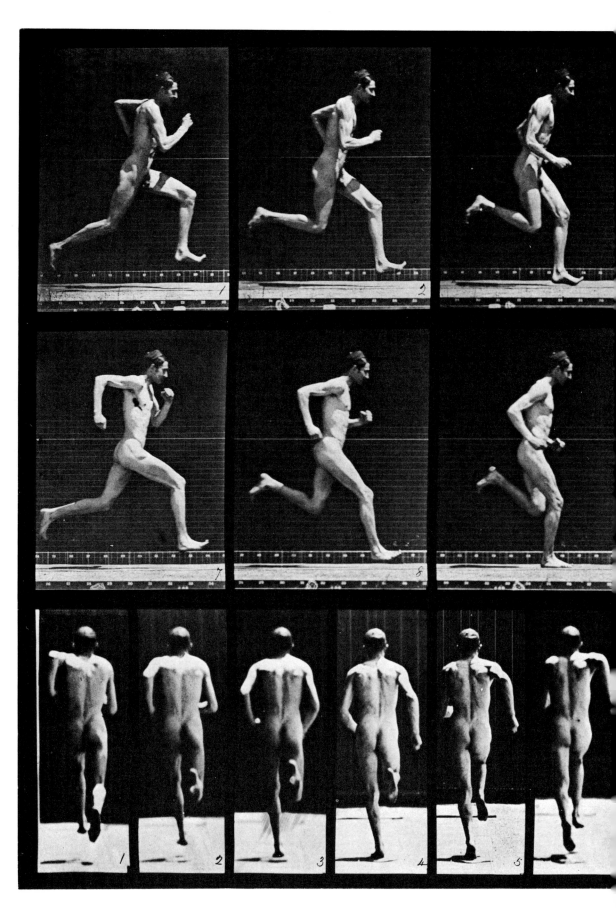

4. *Running at full speed.*

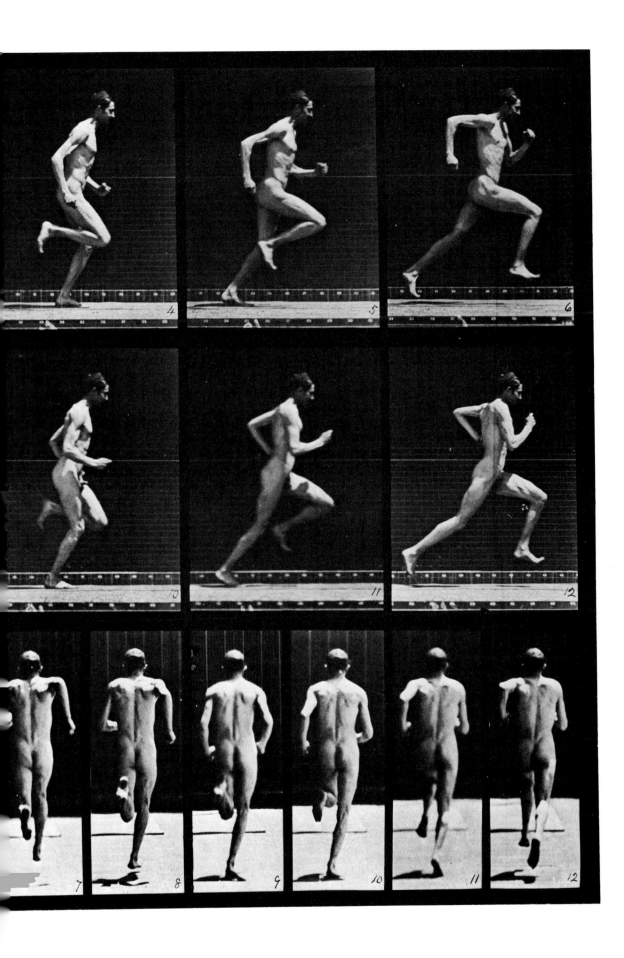

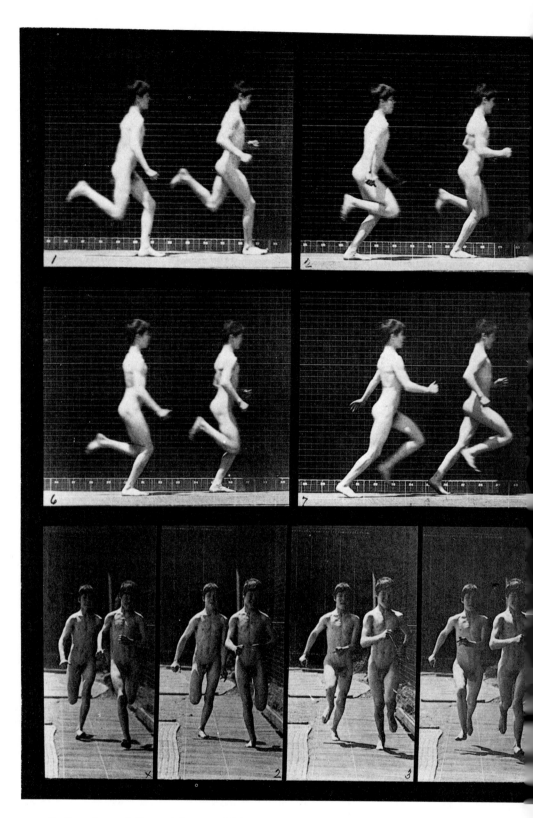

5. *Running at full speed (two models).*

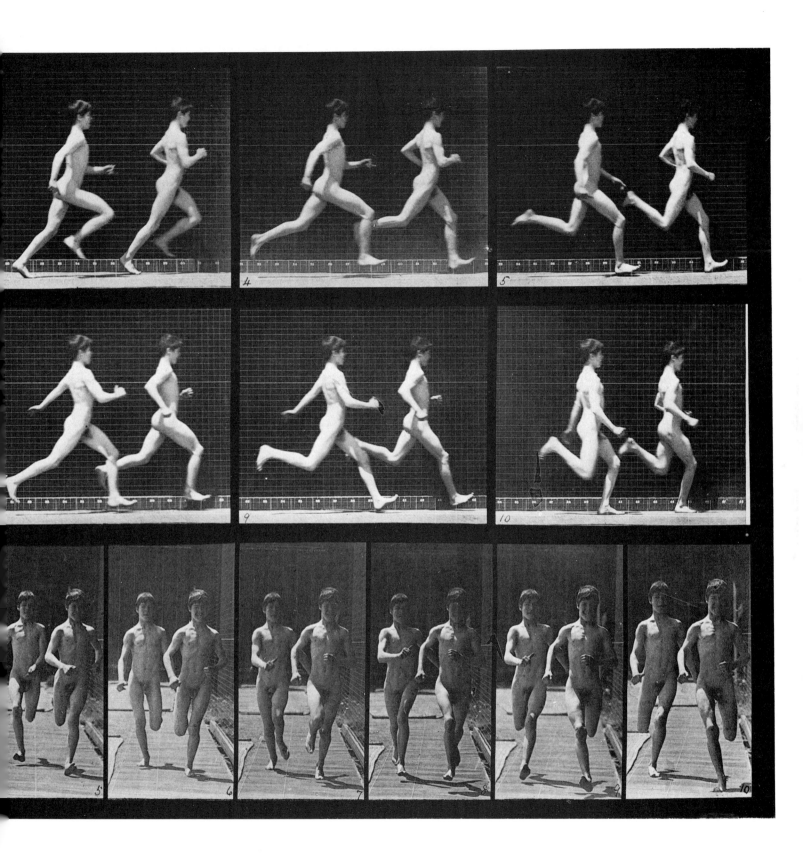

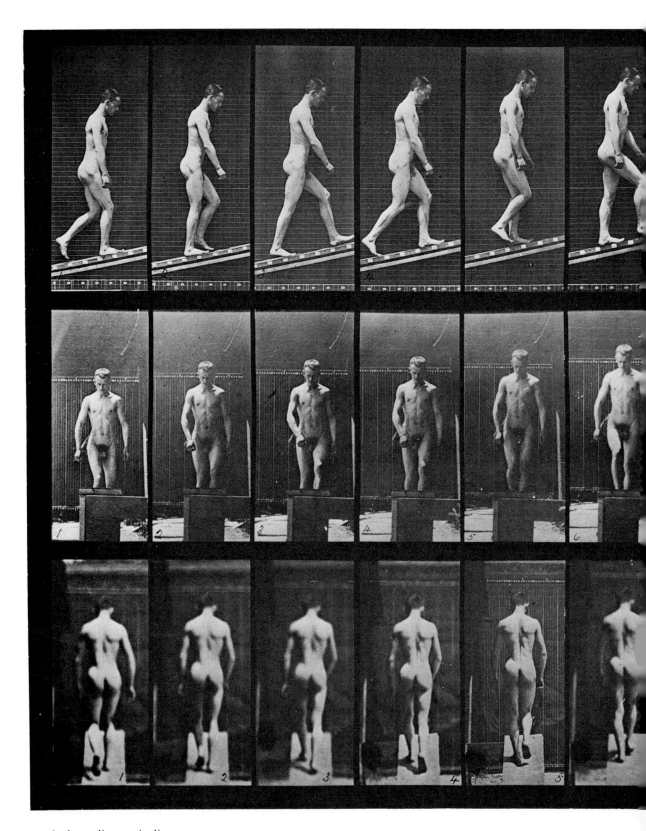

6. *Ascending an incline.*

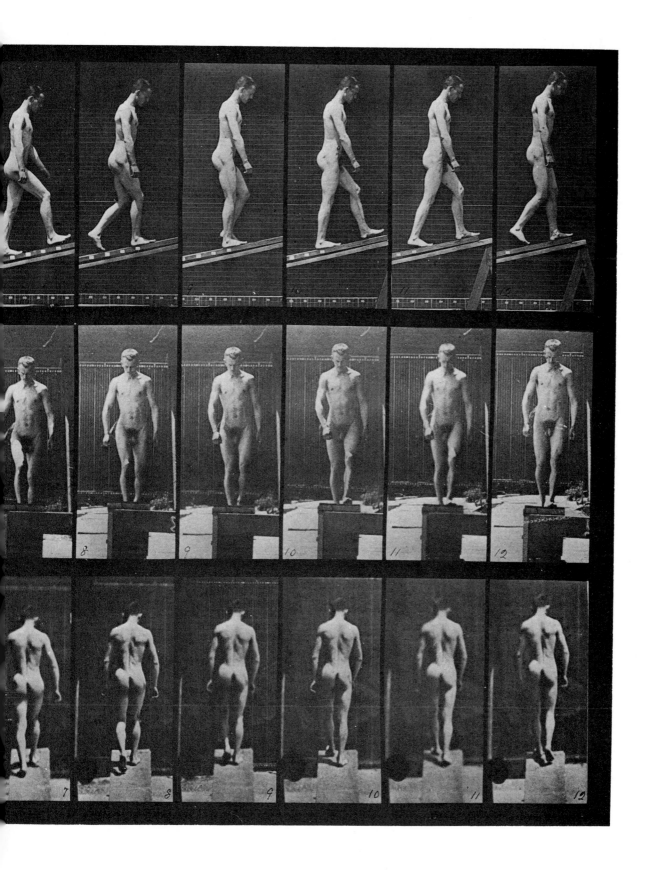

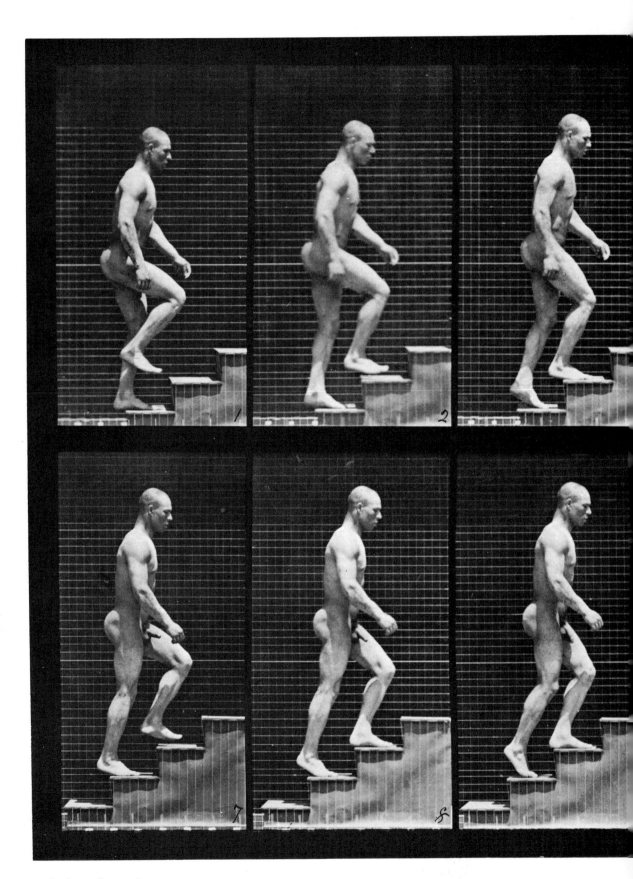

7. *Ascending stairs.*

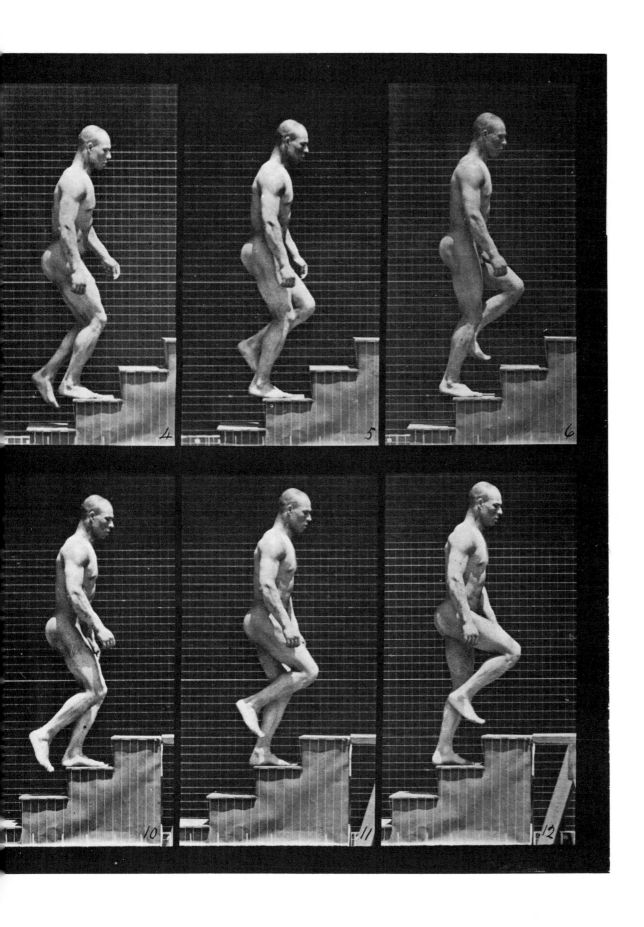

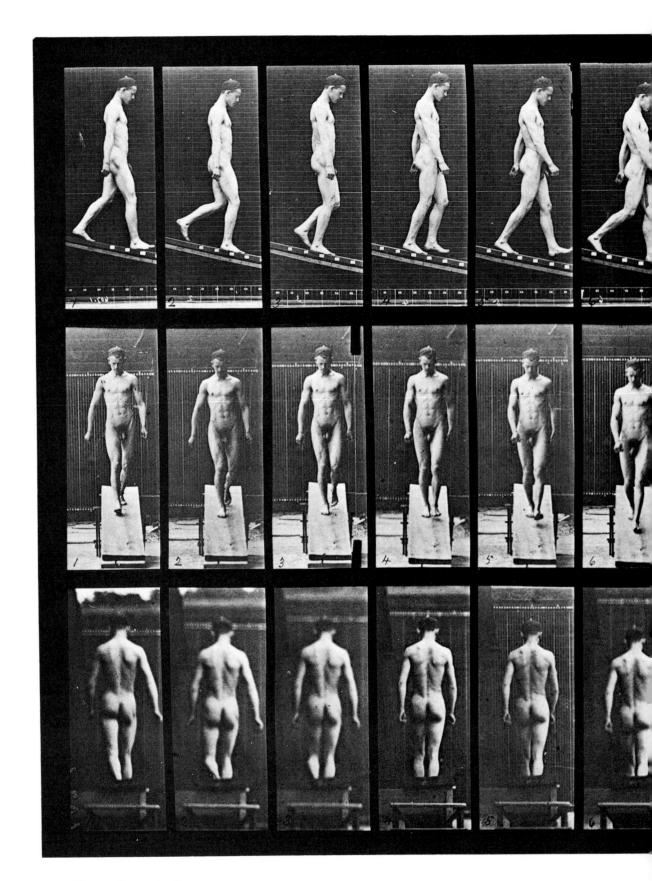

8. *Descending an incline.*

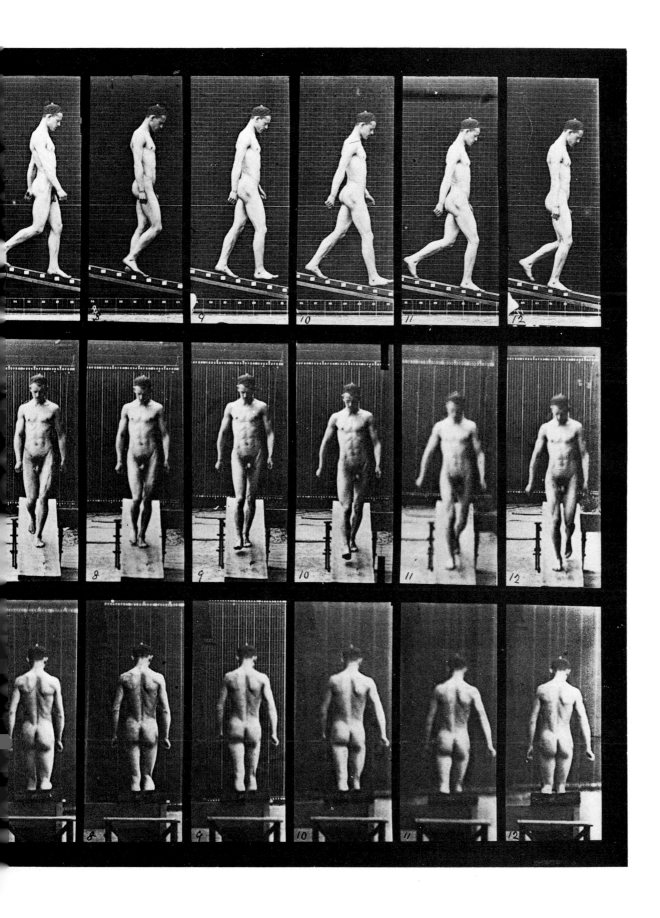

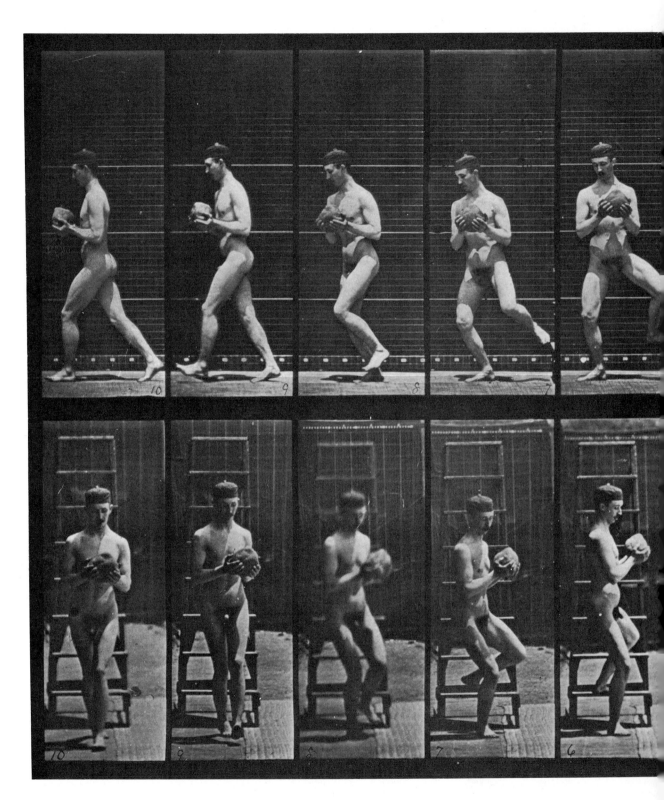

9. *Descending a stepladder and turning around with a rock in hands.*

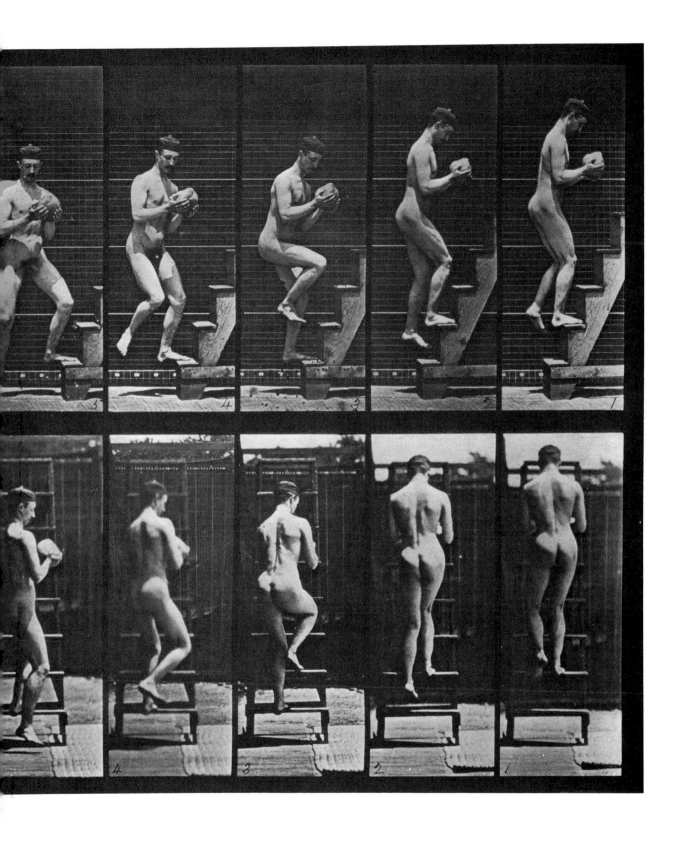

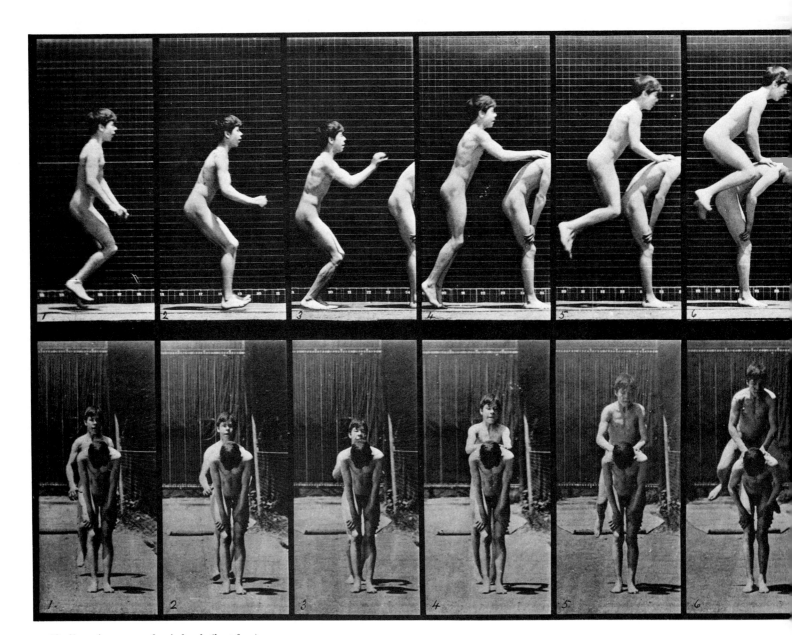

10. *Jumping over a boy's back (leapfrog).*

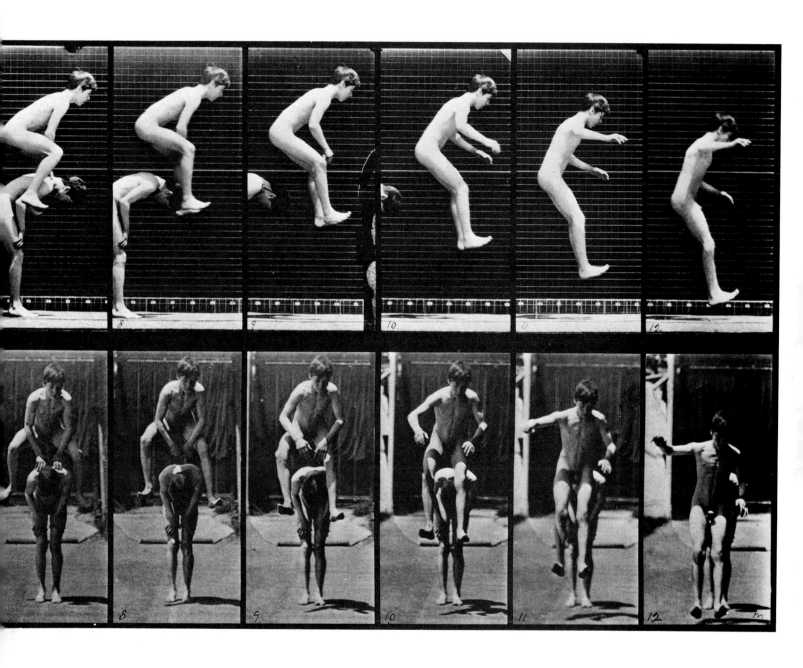

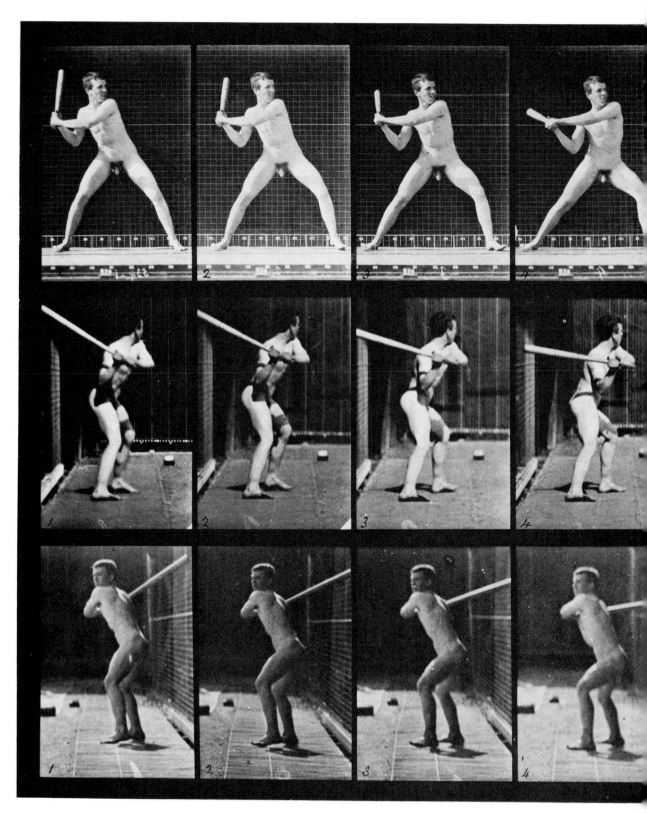

11. Baseball: batting.

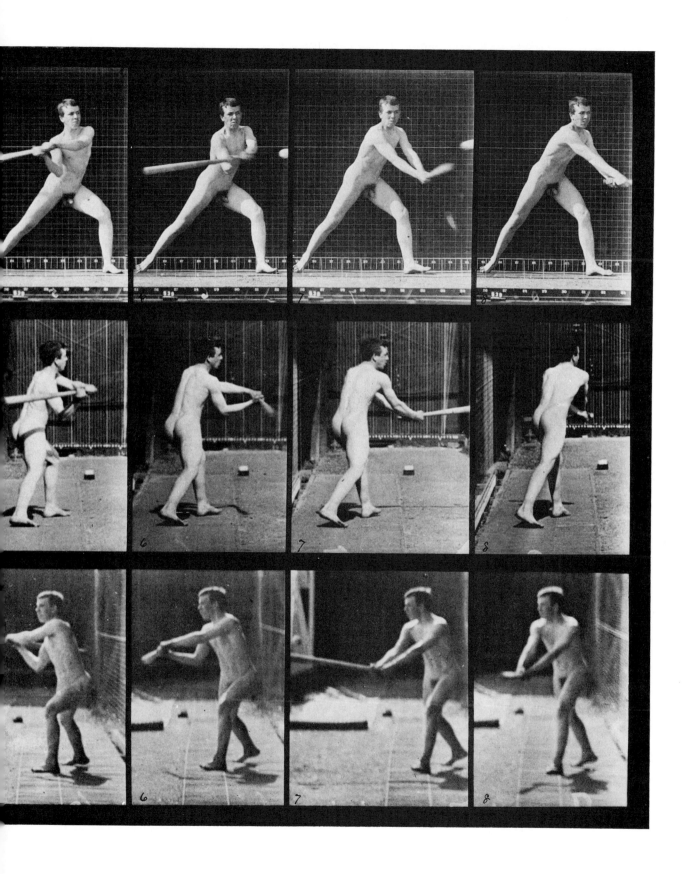

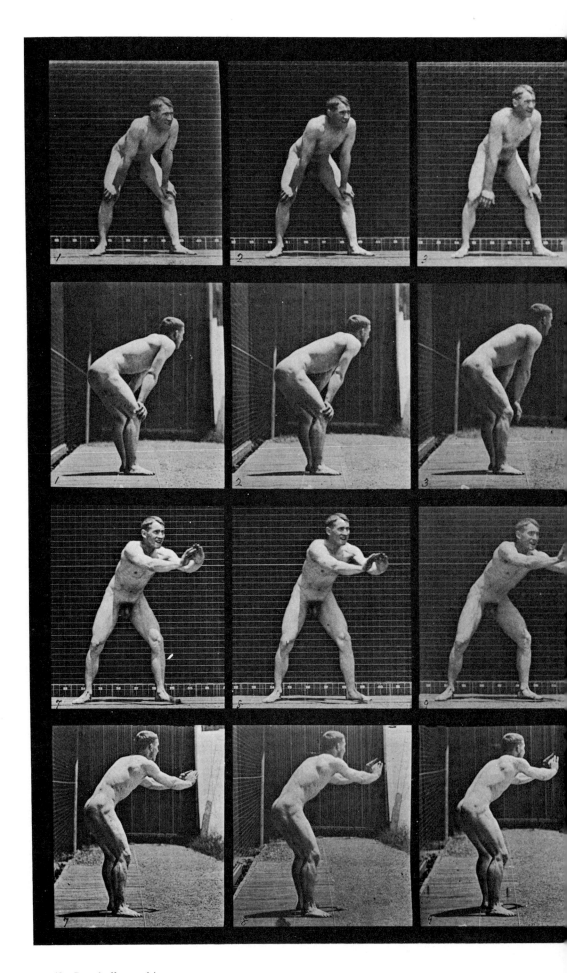

12. *Baseball: catching.*

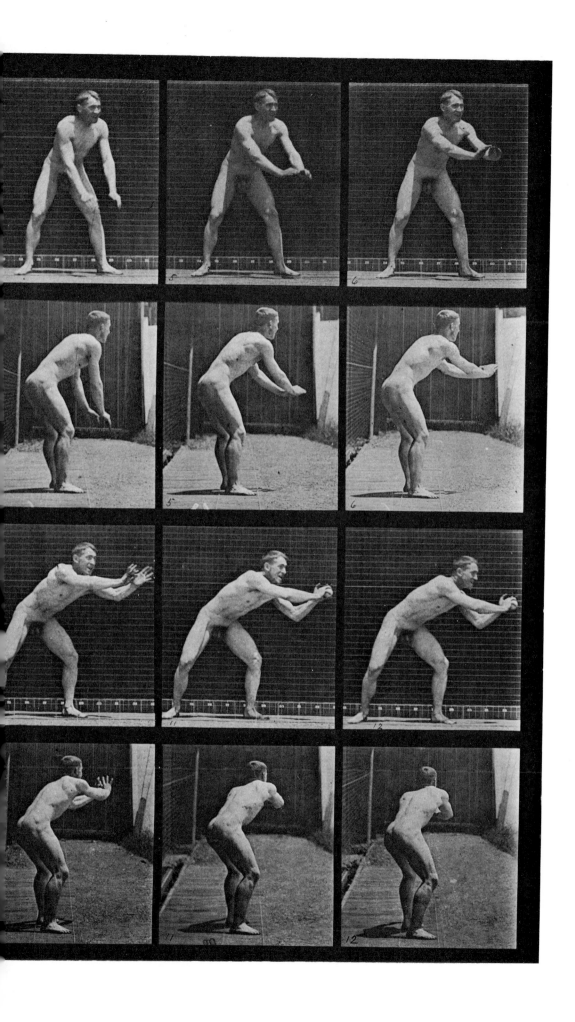

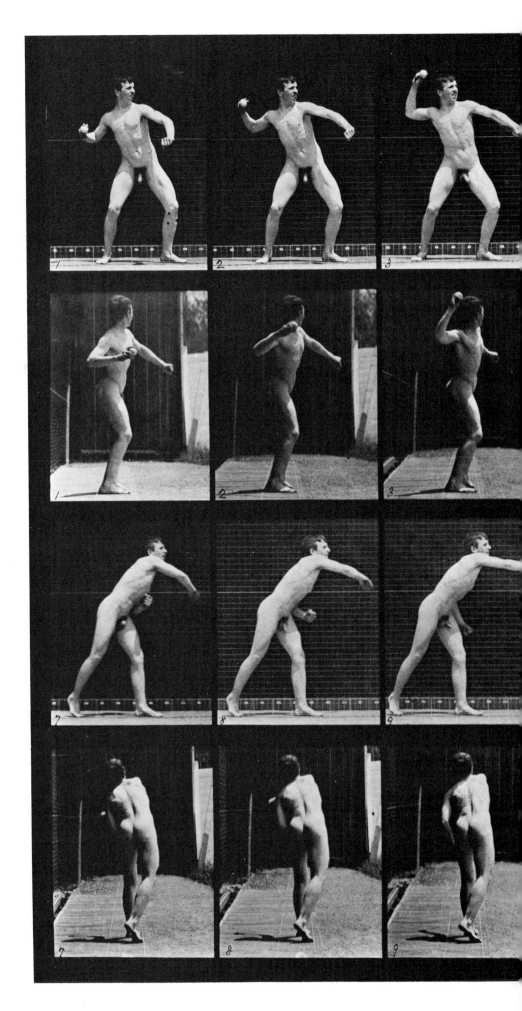

13. Baseball: throwing.

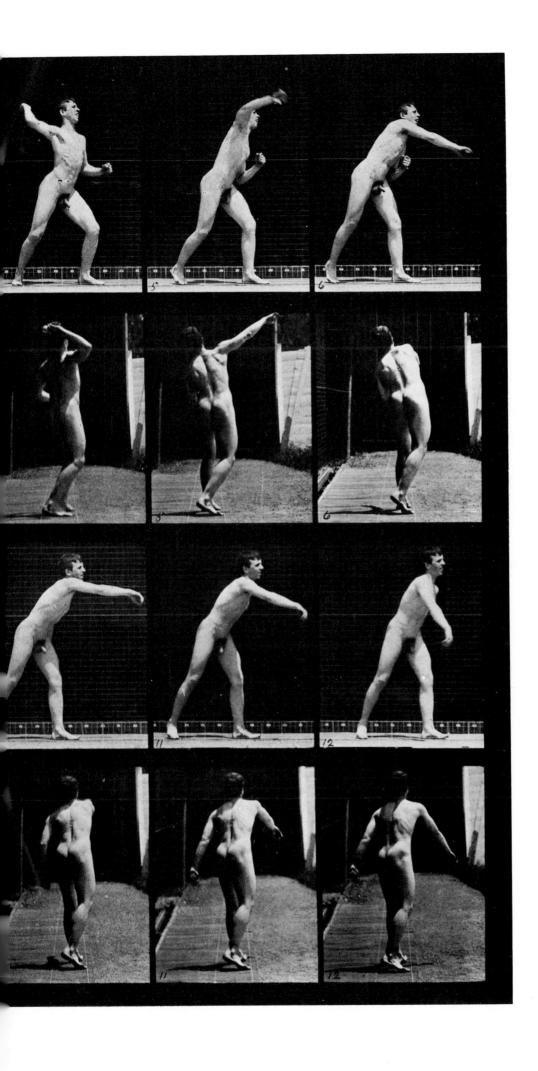

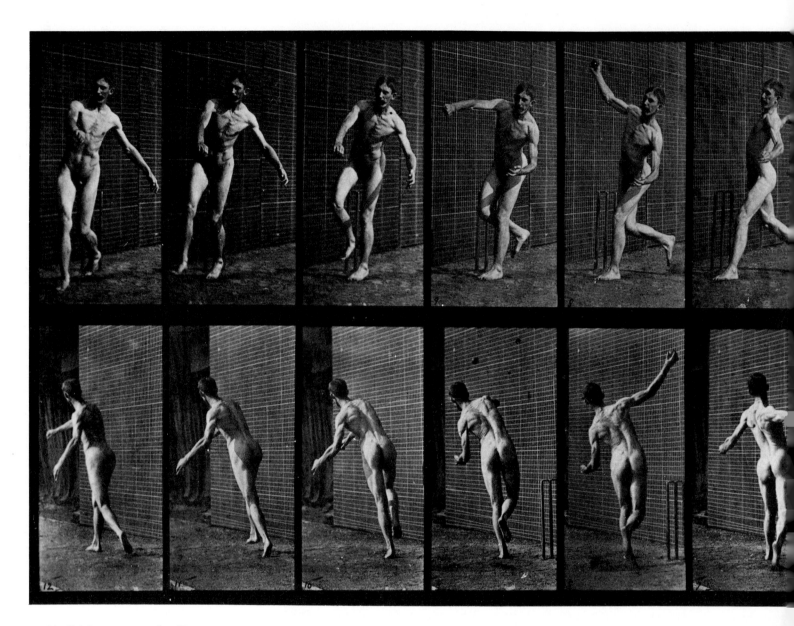

14. Cricket: overarm bowling.

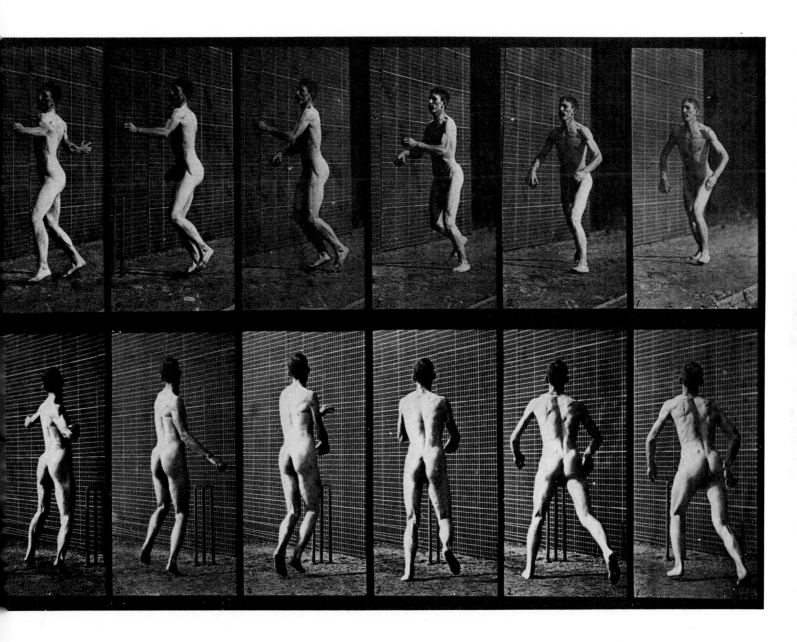

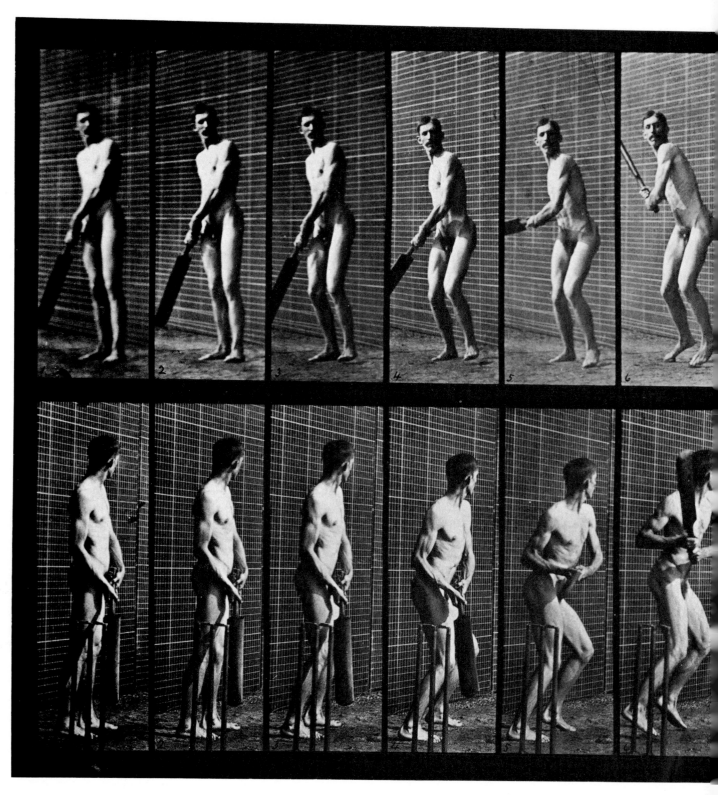

15. *Cricket: batting and drive.*

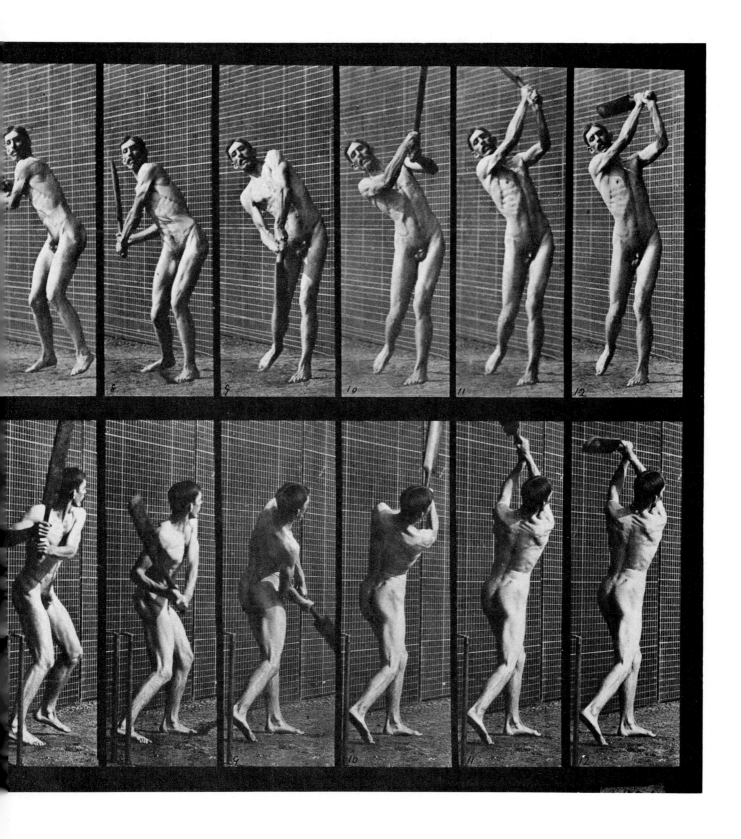

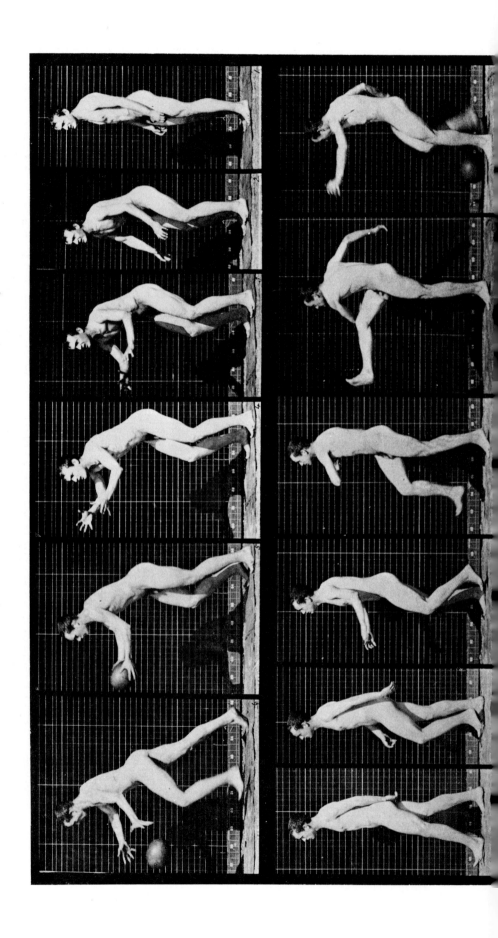

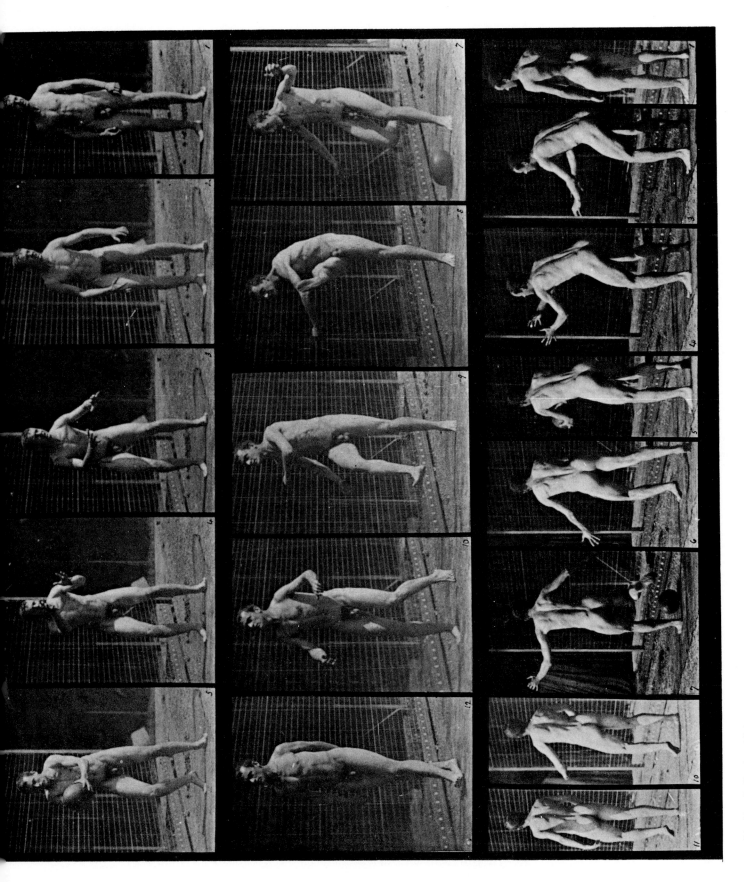

16. Football: dropkick.

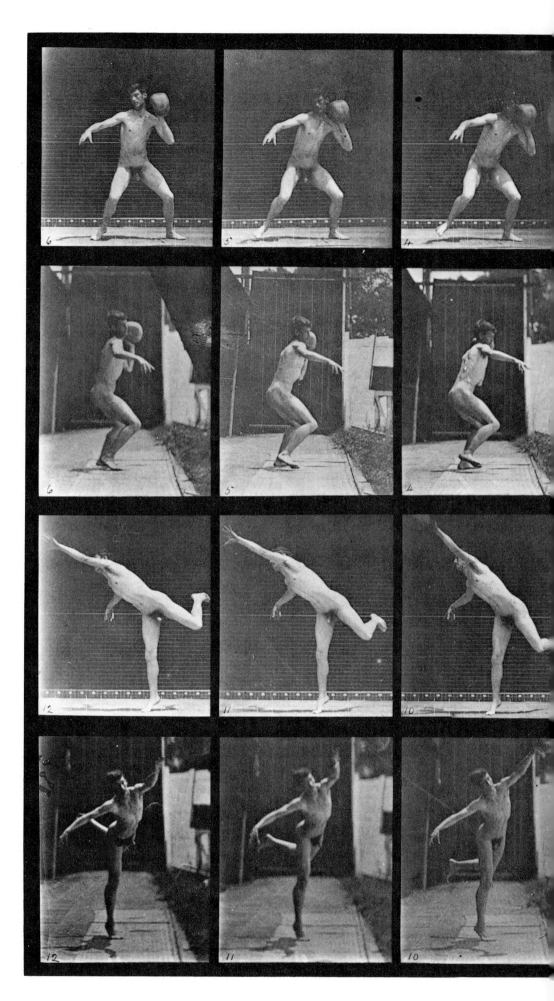

17. *Heaving a 20-lb. rock.*

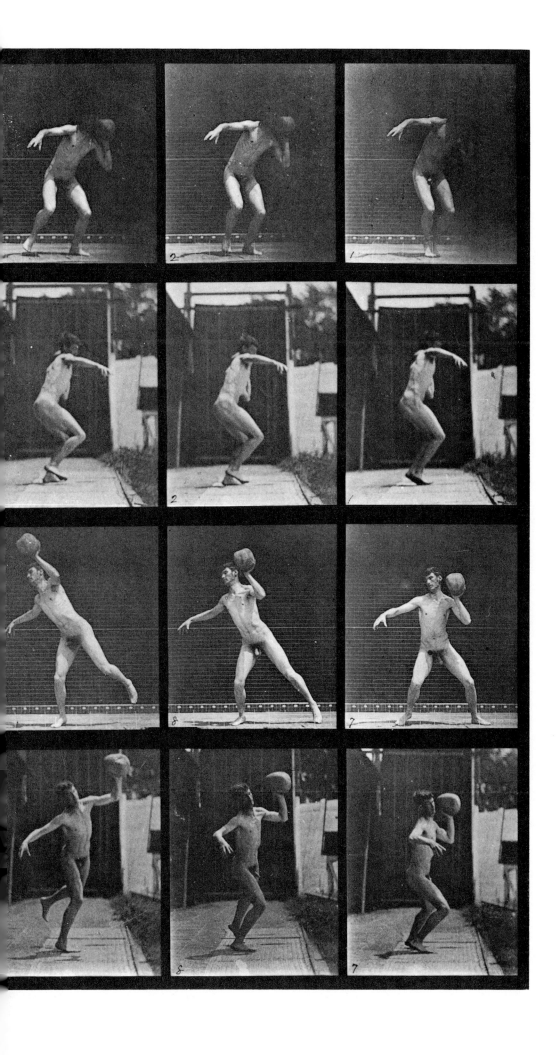

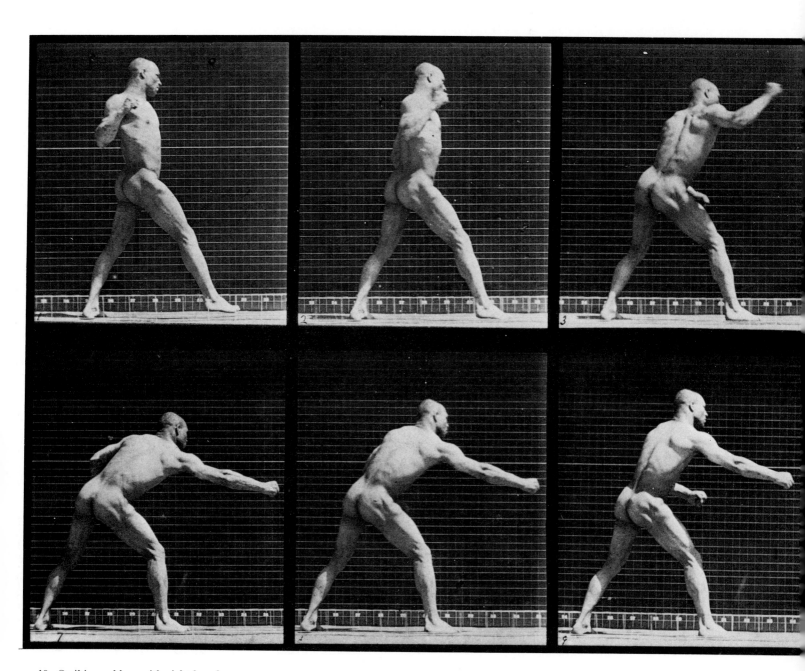

18. *Striking a blow with right hand.*

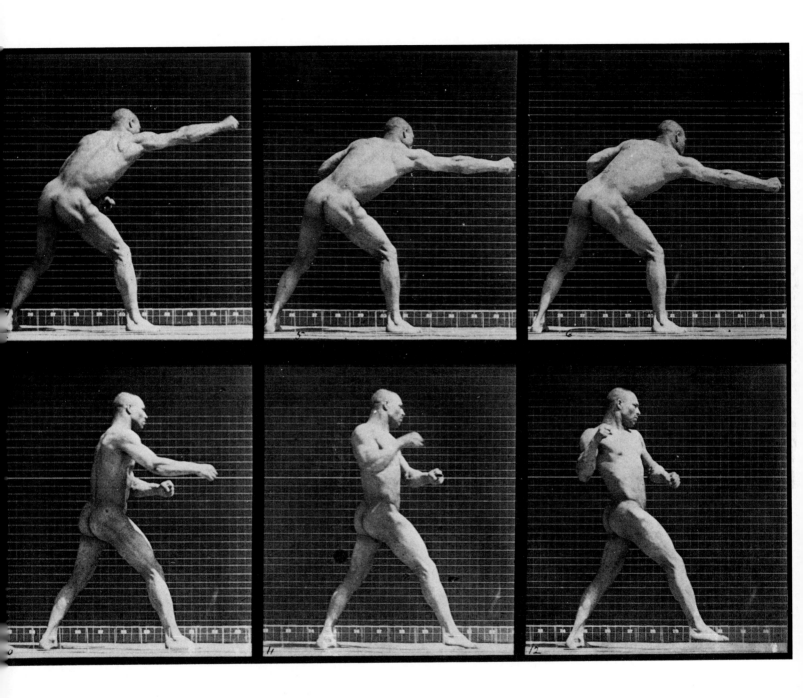

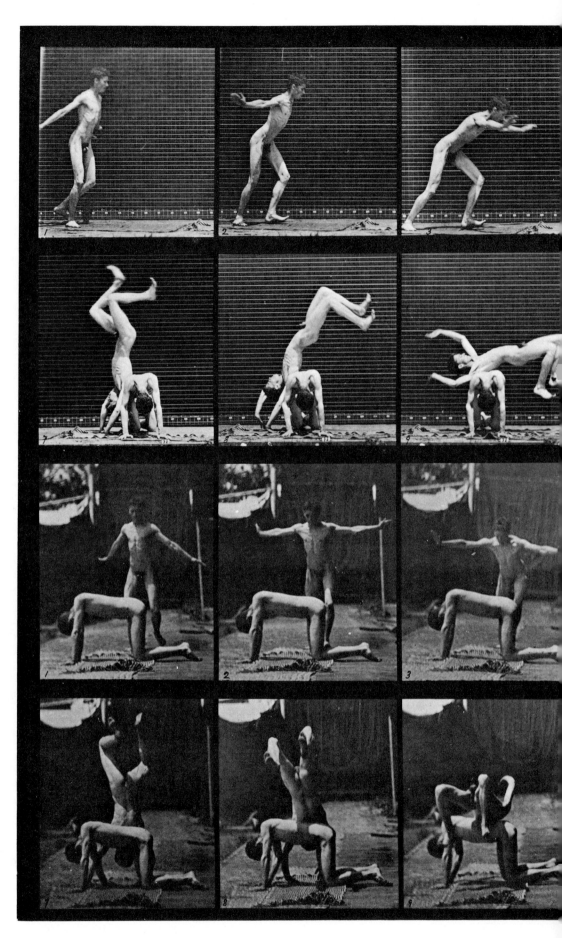

19. *Handspring over a man's back.*

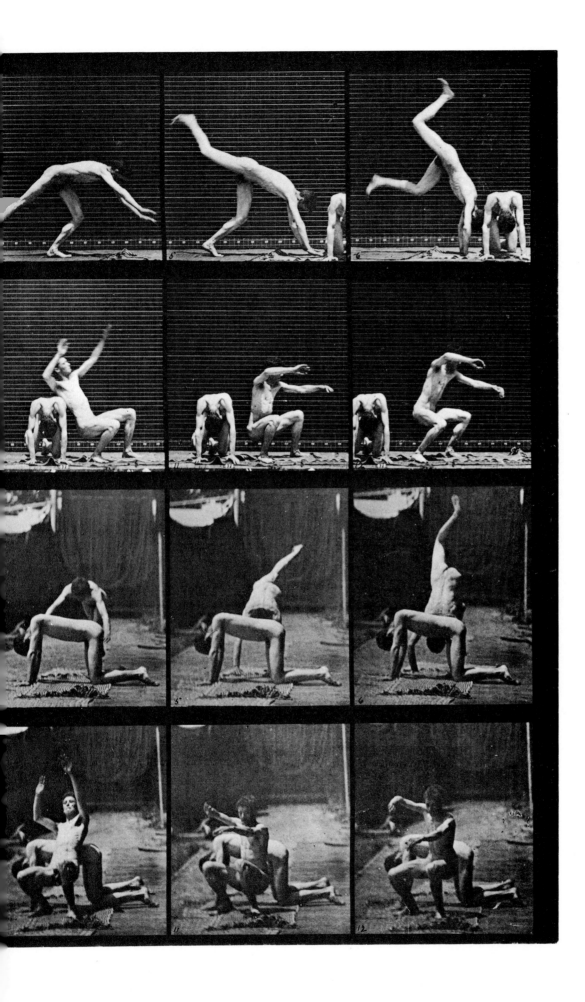

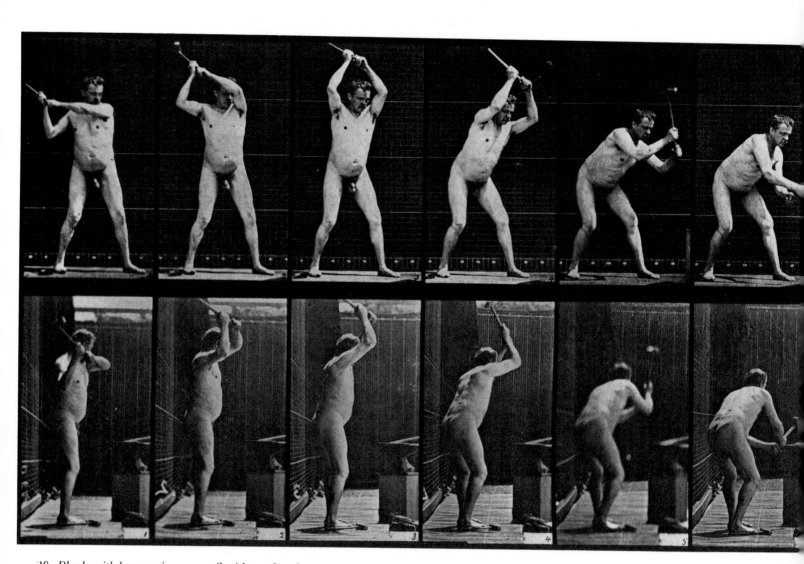

20. *Blacksmith hammering on anvil with two hands.*

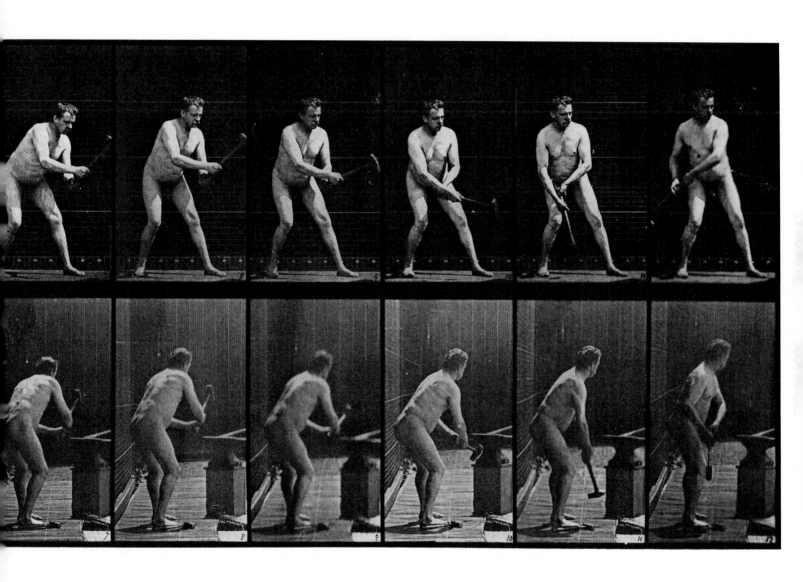

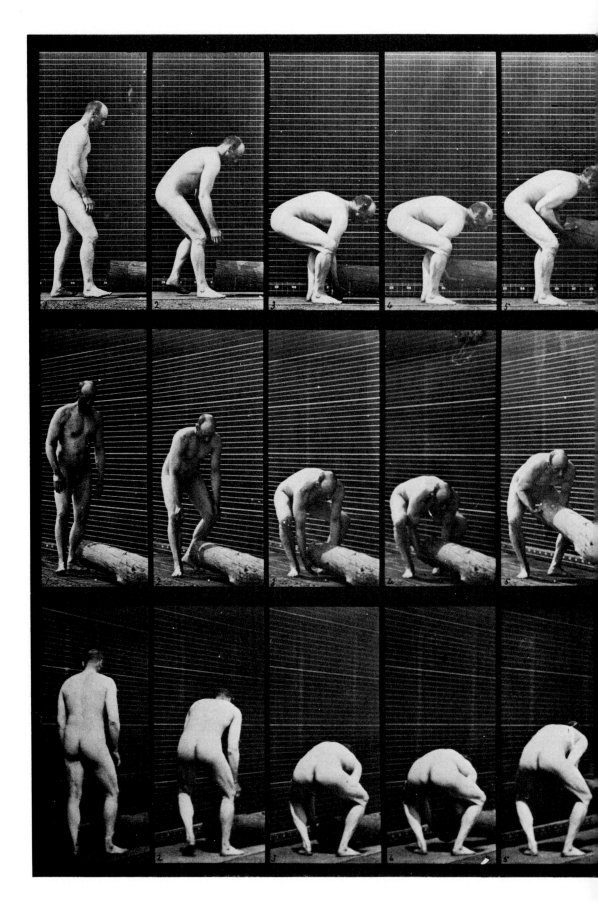

21. *Lifting a log on end.*

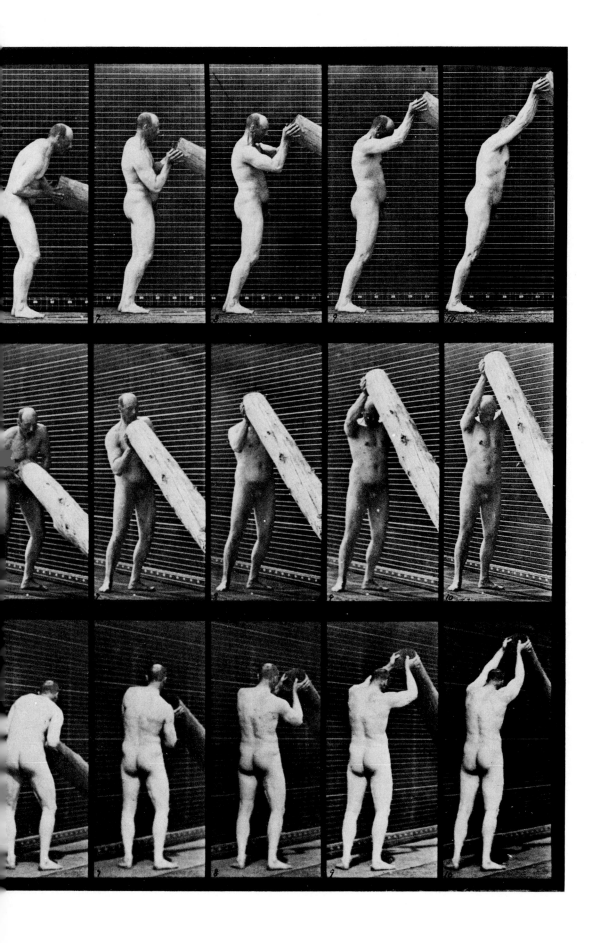

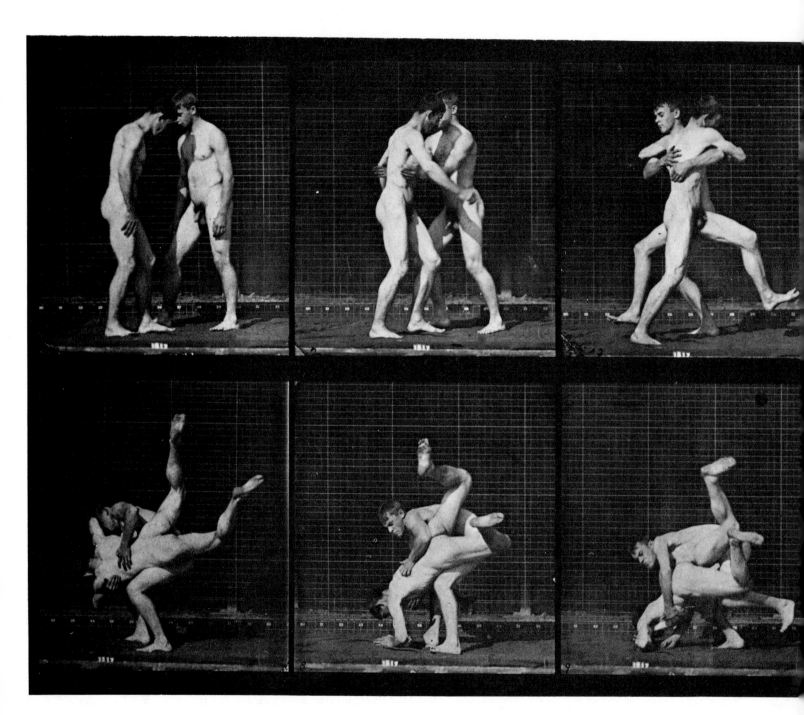

22. *Wrestling: Graeco-Roman.*

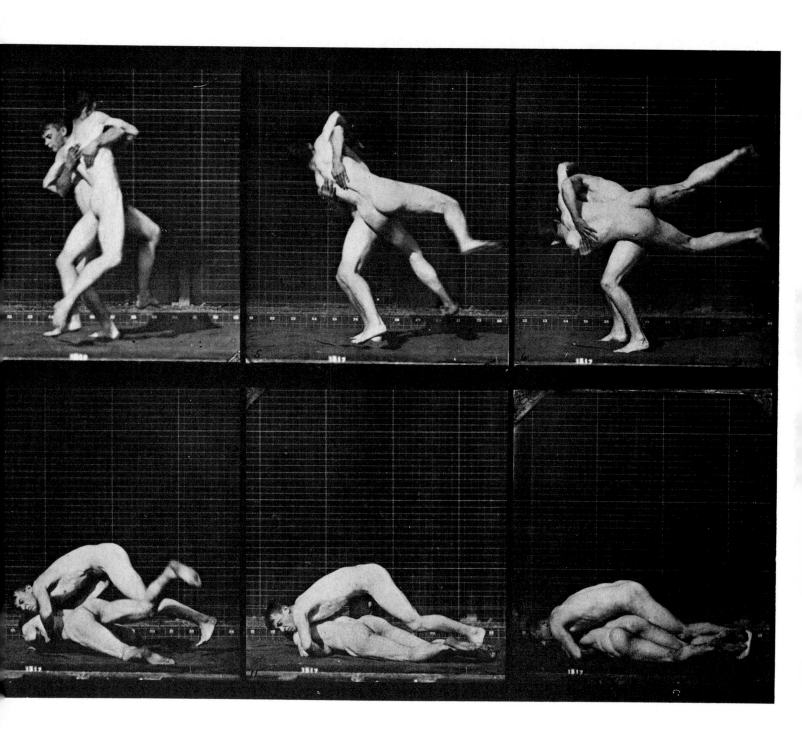

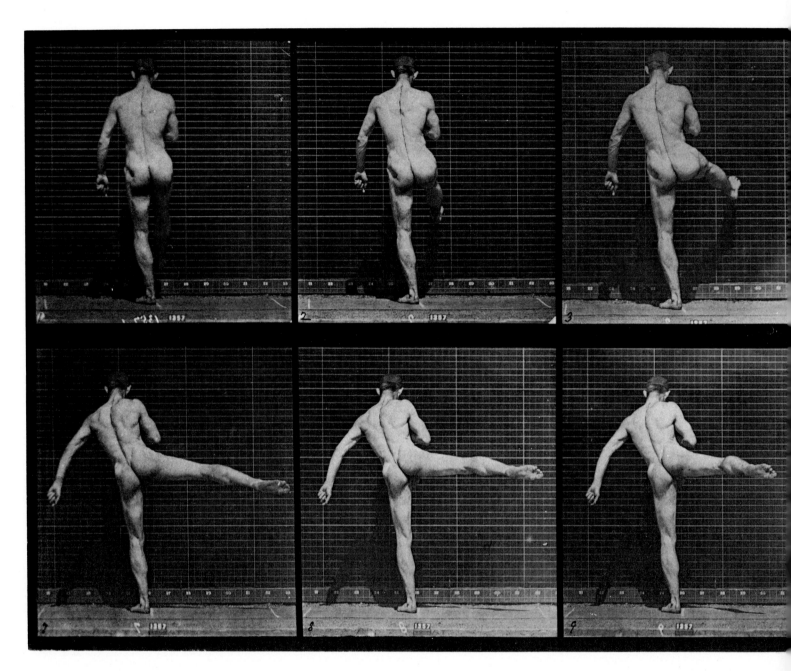

23. *First ballet action.*

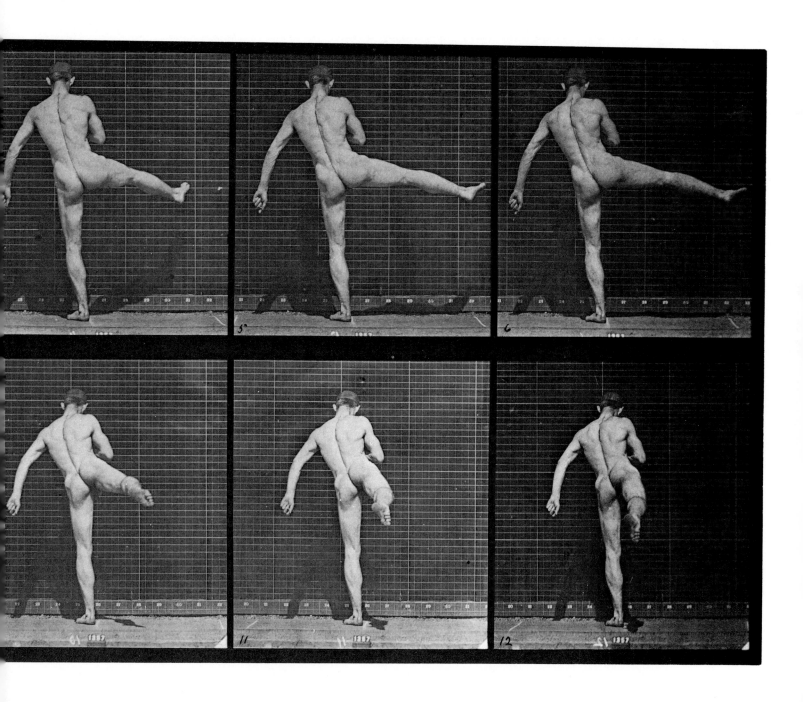

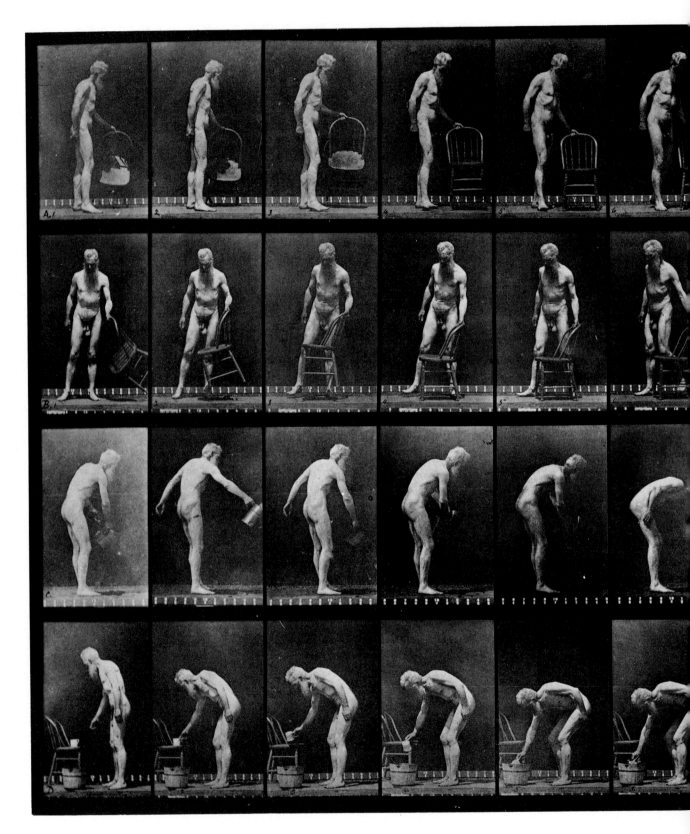

24. A, B: Sitting down. C: Sprinkling water. D: Stooping for cup and drinking.
 (The model is Muybridge.)

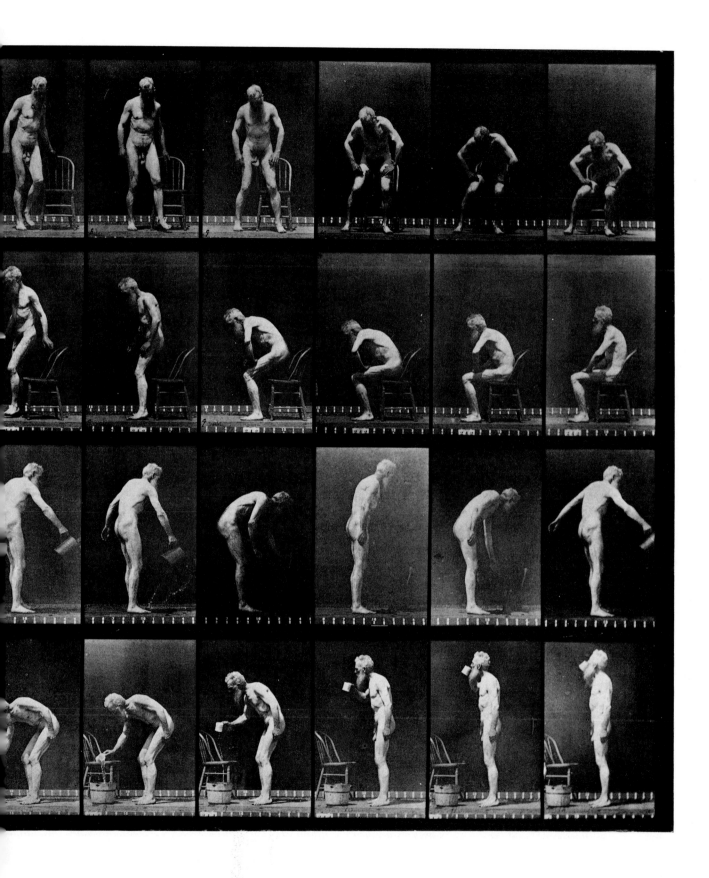

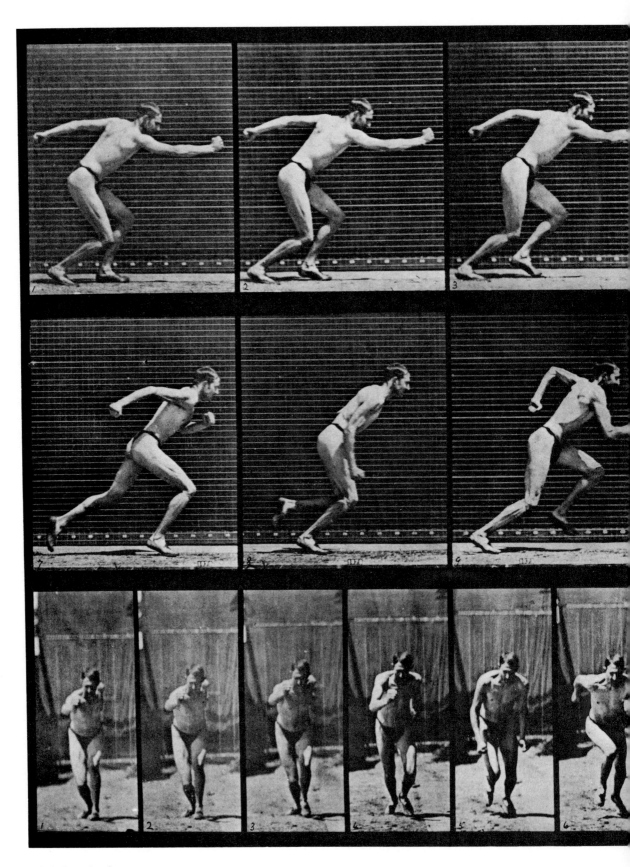

25. *Starting for a run.*

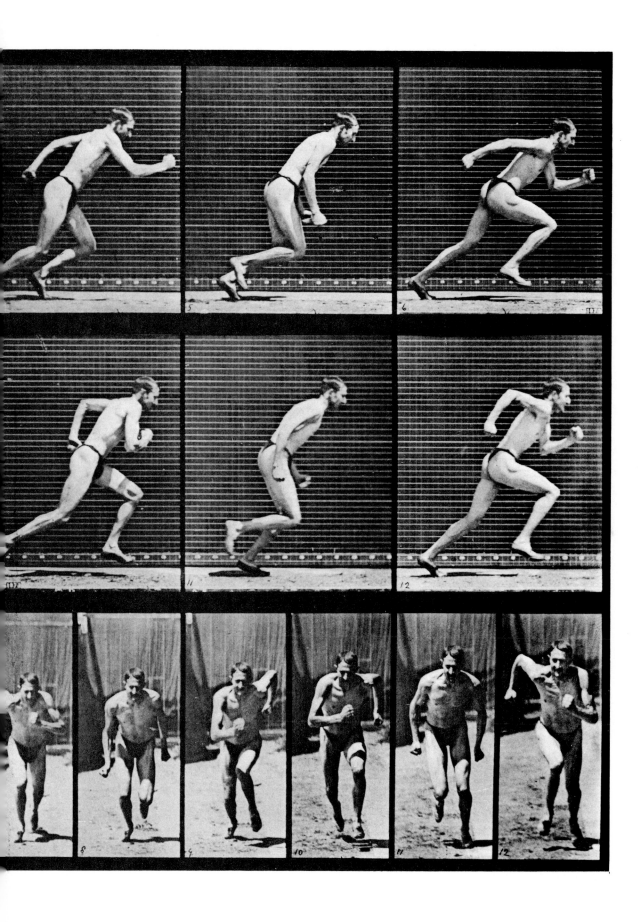

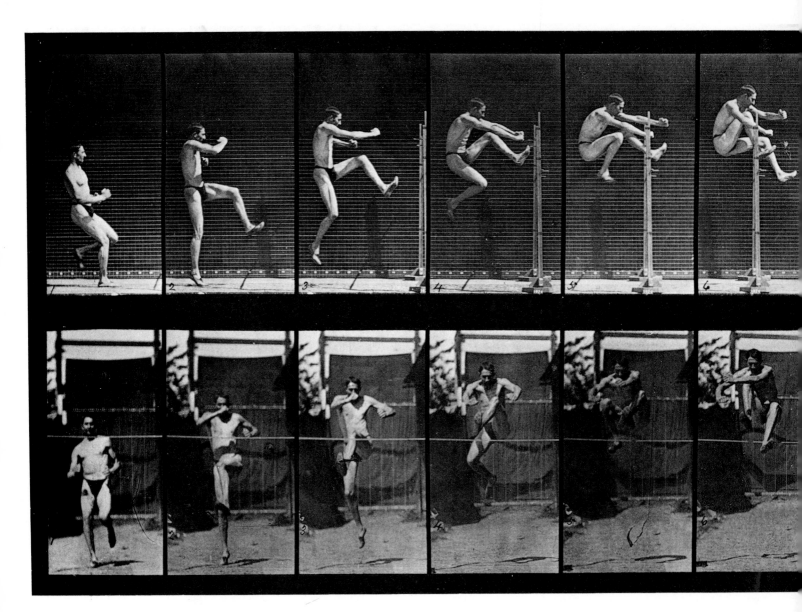

26. *Jumping: running straight high jump.*

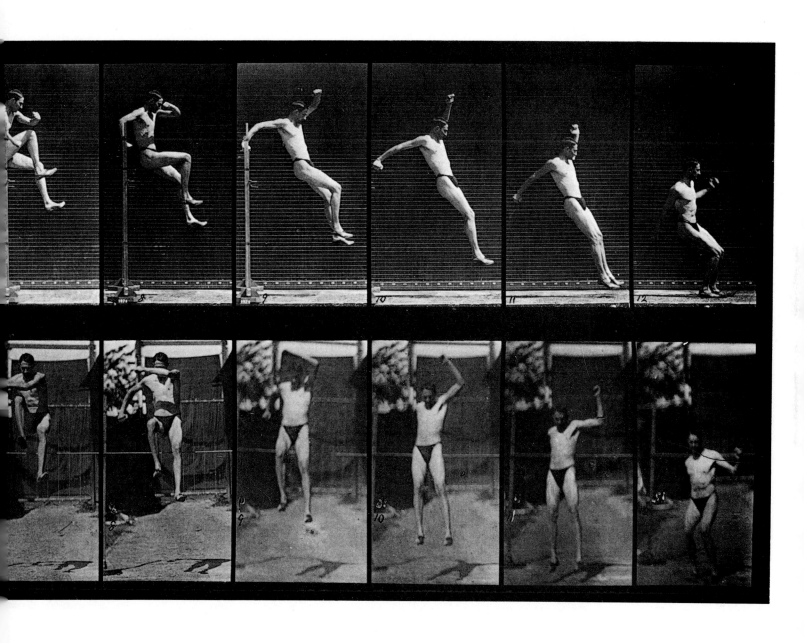

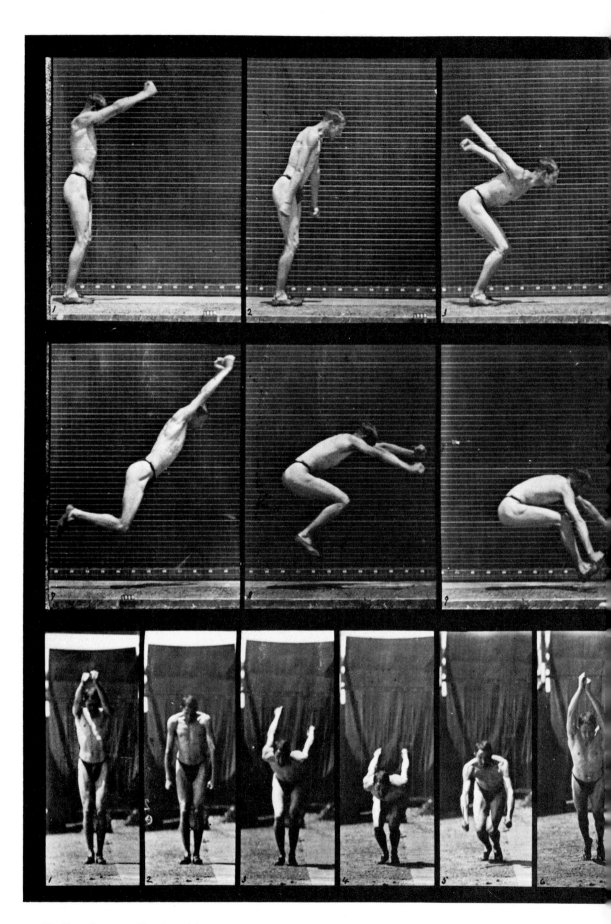

27. *Jumping: standing broad jump.*

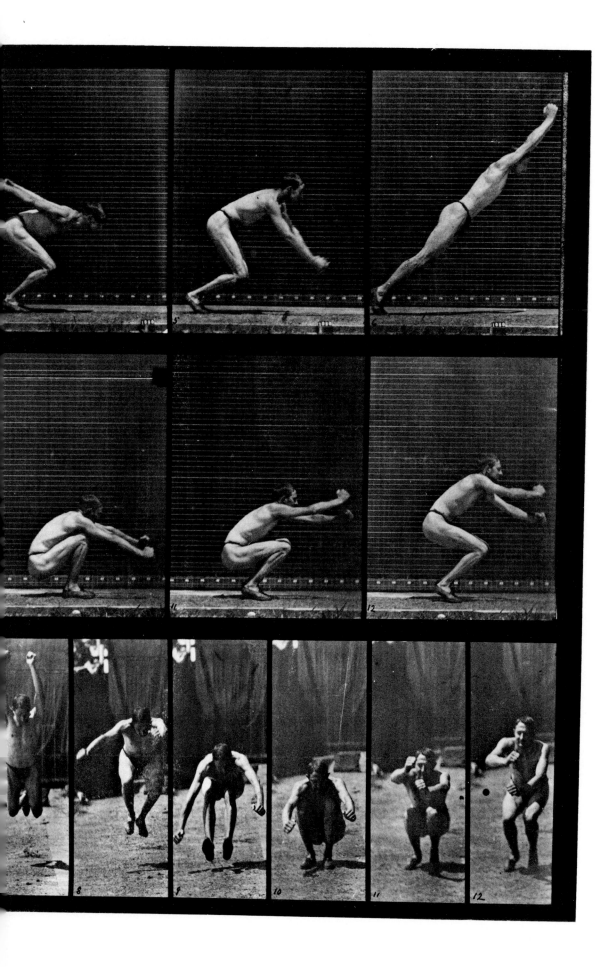

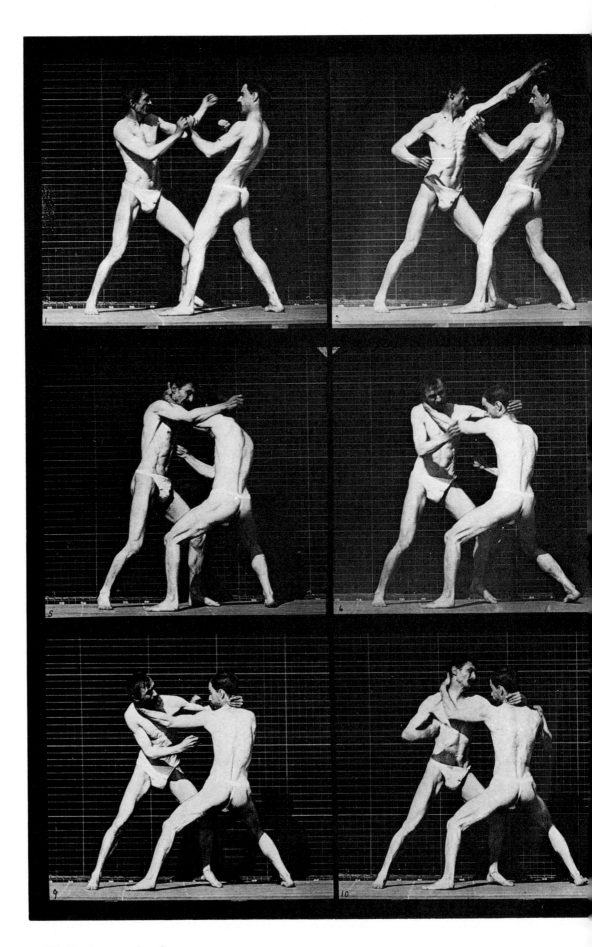

28. *Boxing: open hand.*

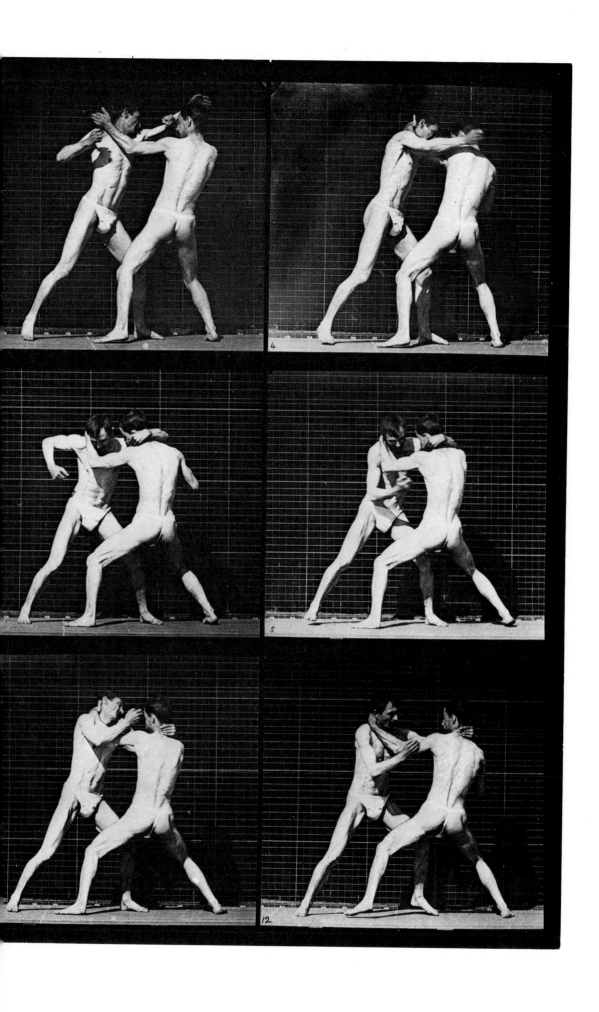

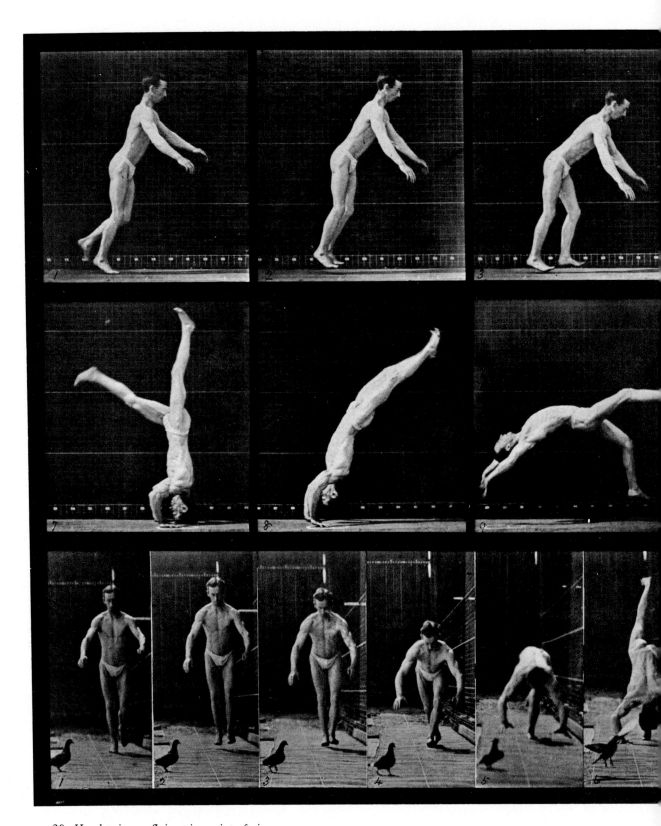

29. *Headspring: a flying pigeon interfering.*

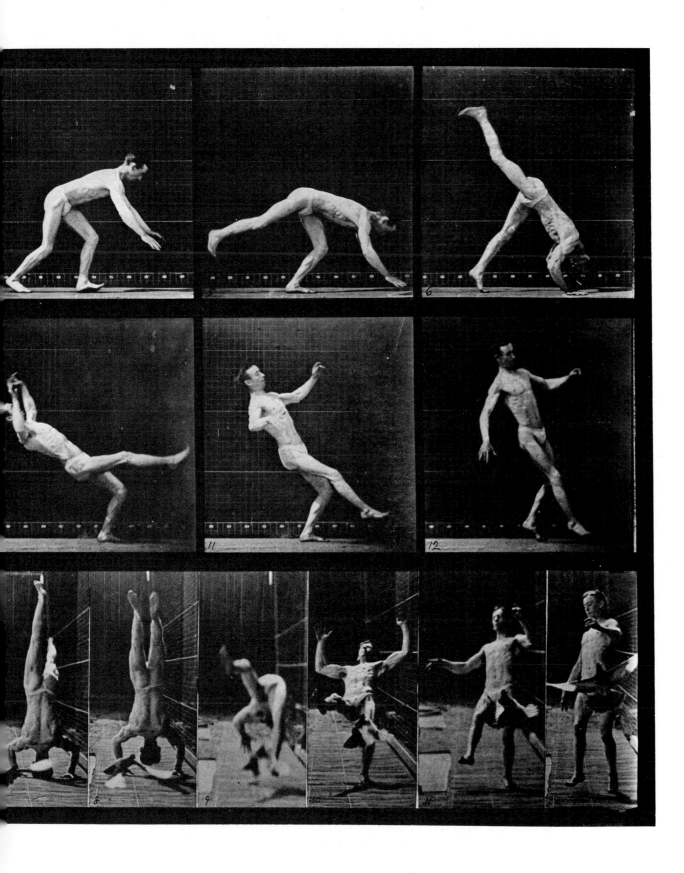

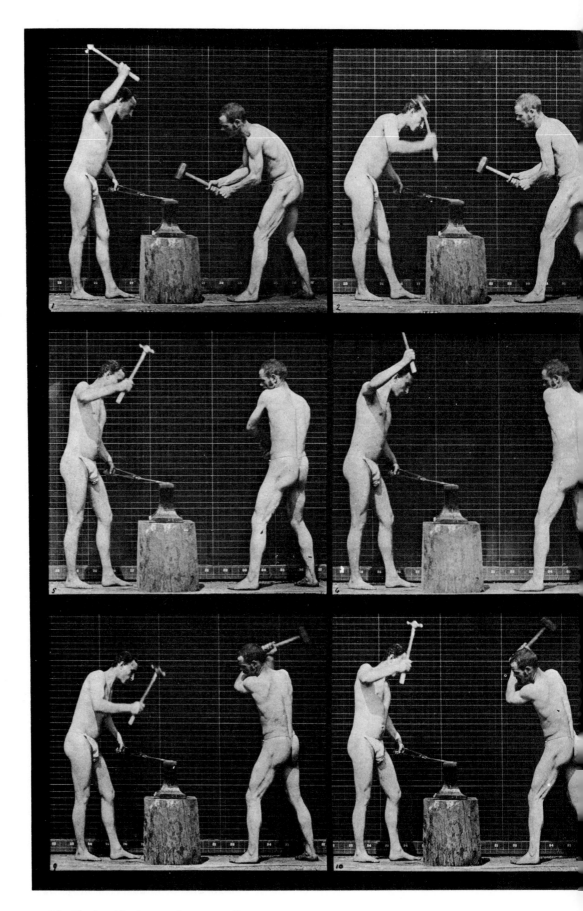

30. *Blacksmiths hammering on anvil.*

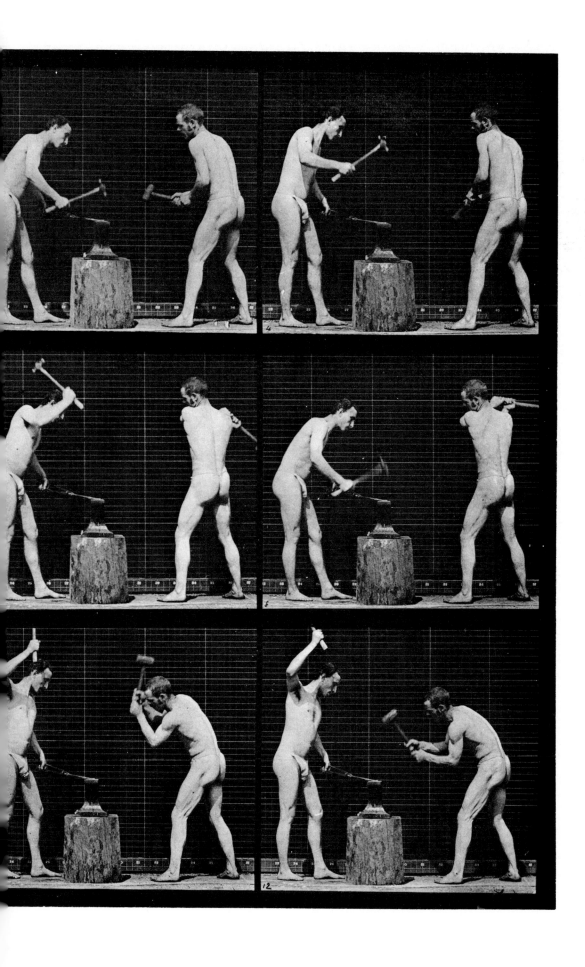

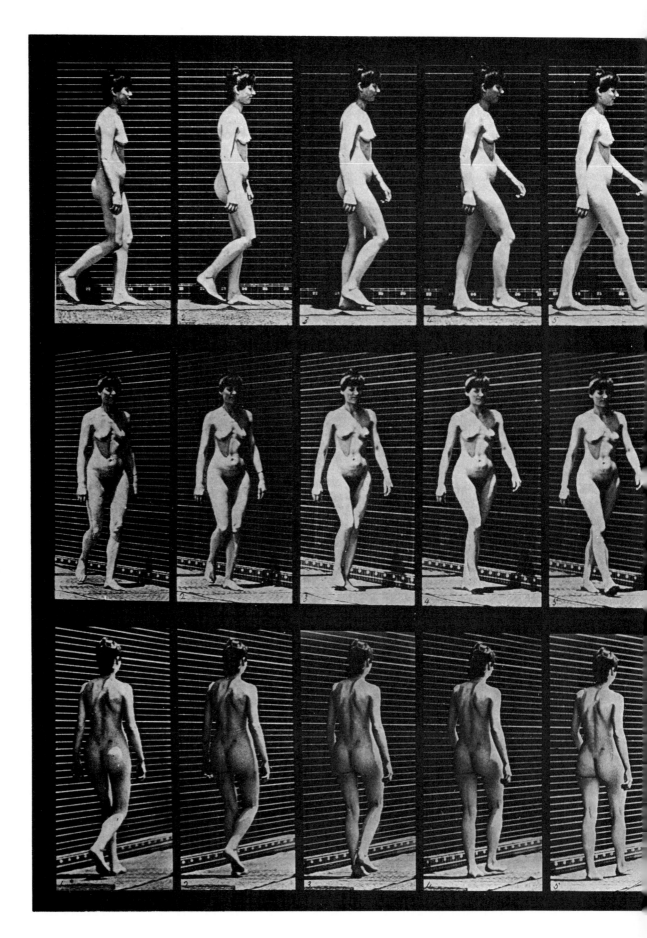

31. Walking.

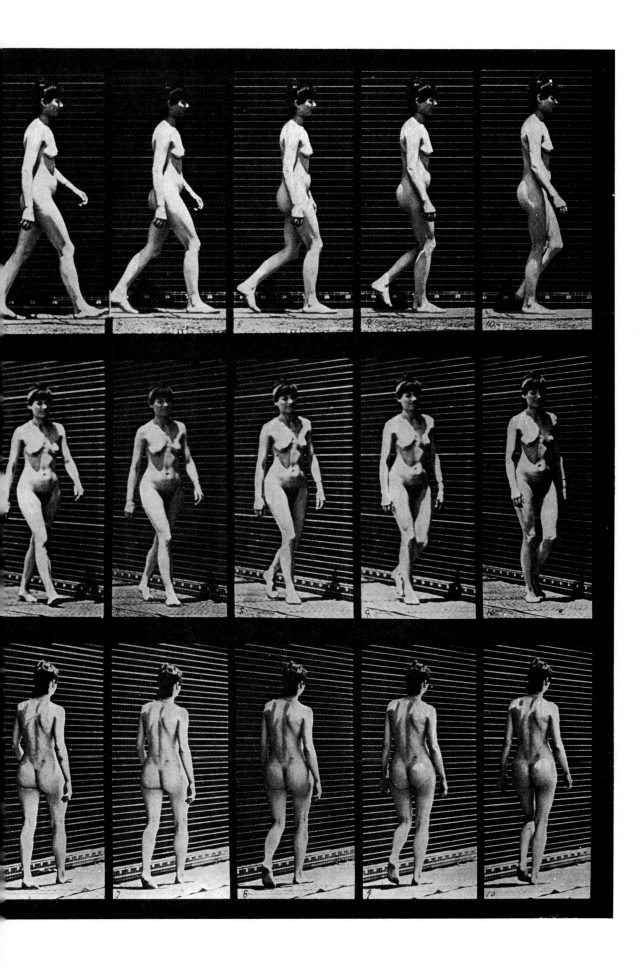

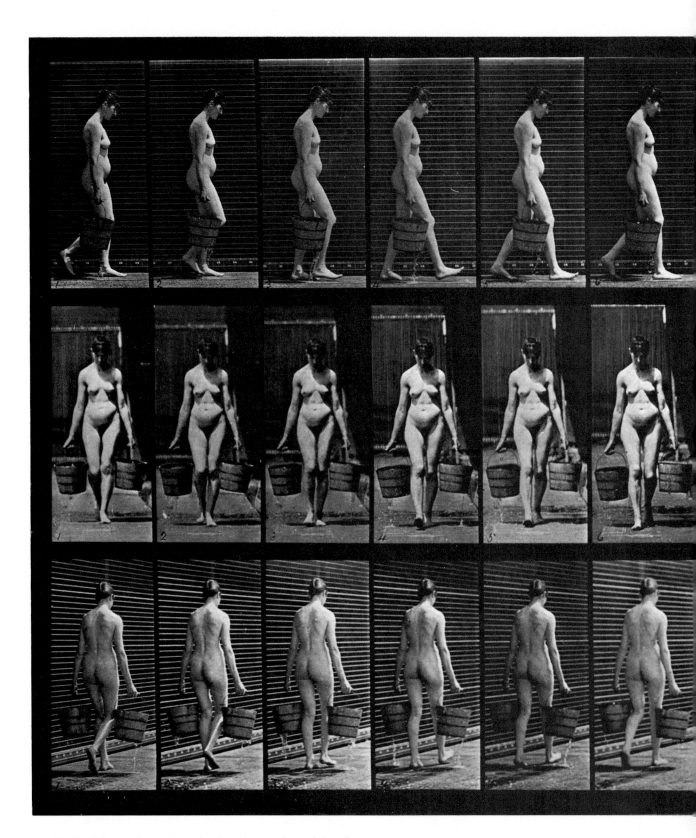

32. *Walking and carrying a bucket of water in each hand.*

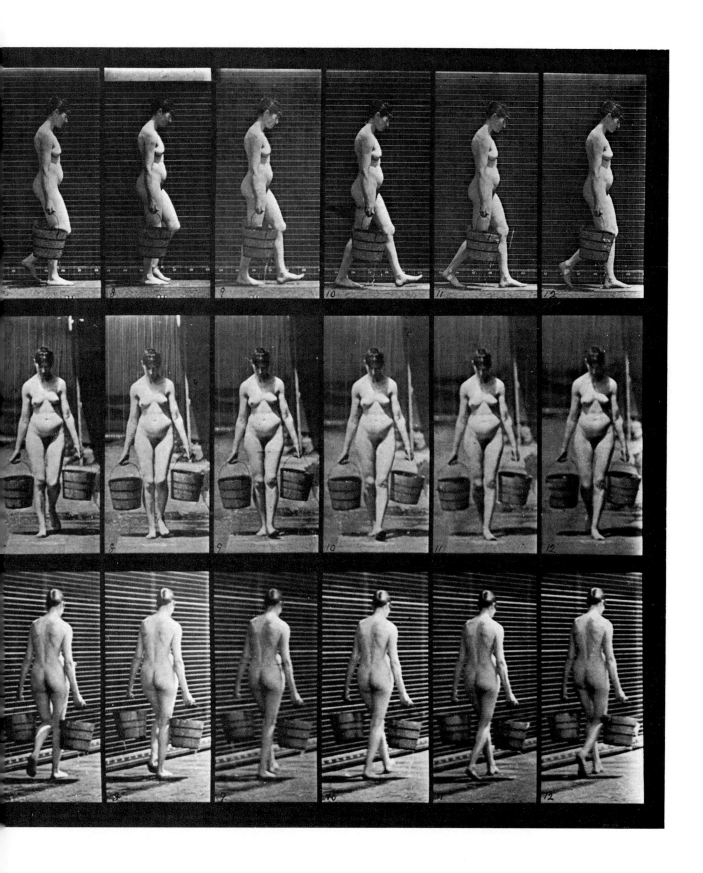

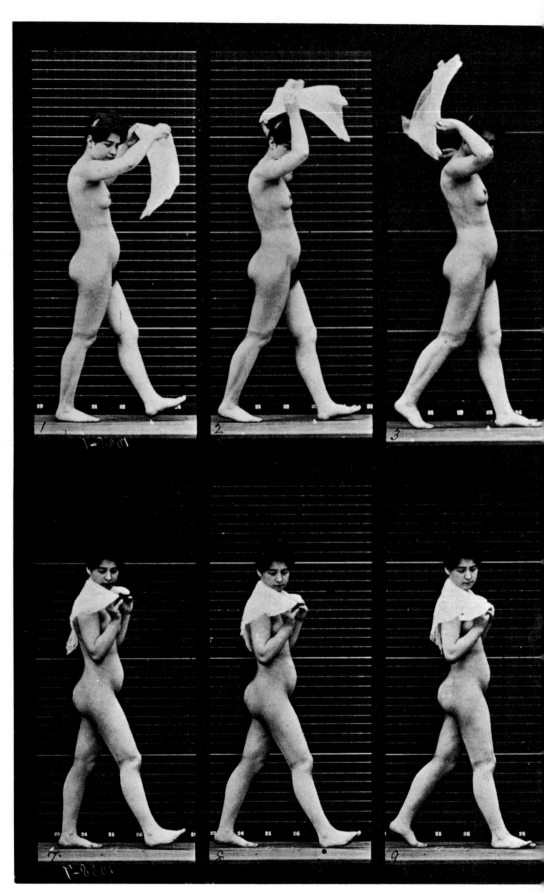

33. *Walking and throwing a handkerchief over shoulders.*

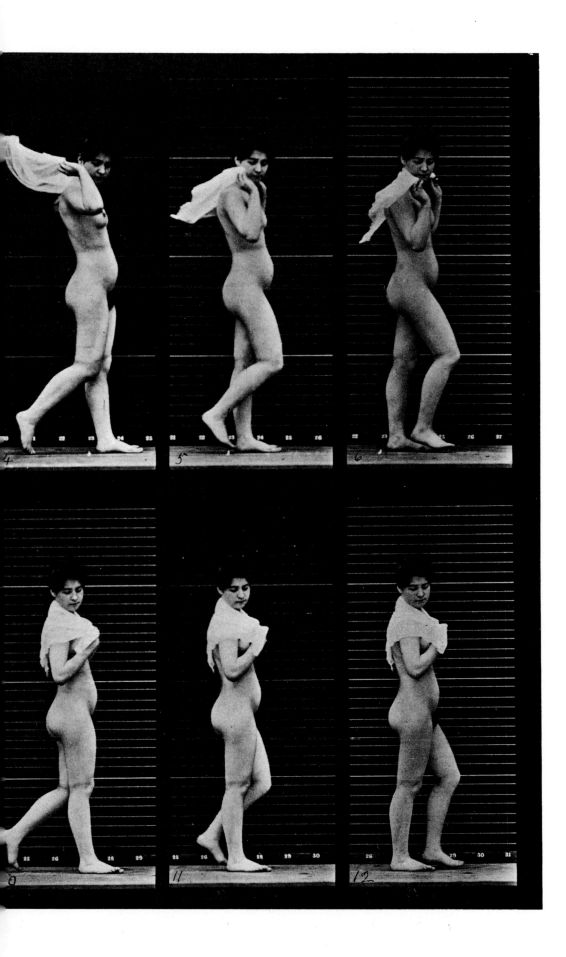

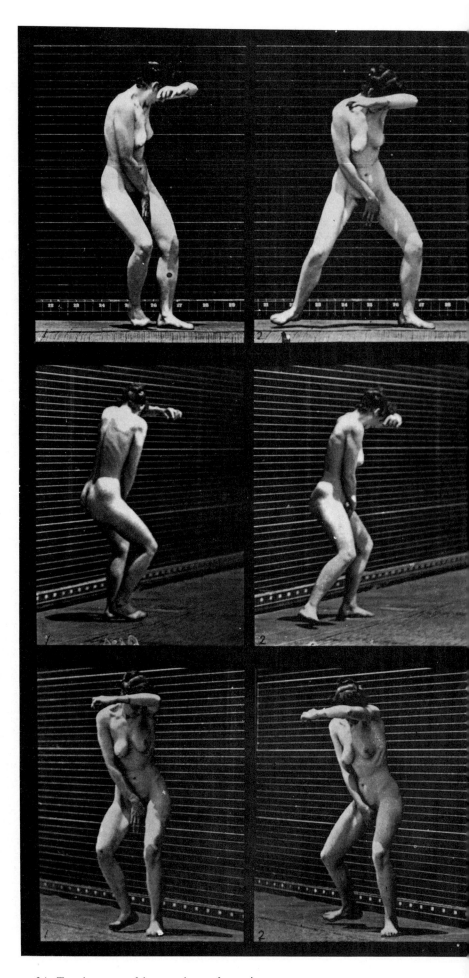

34. Turning around in surprise and running away.

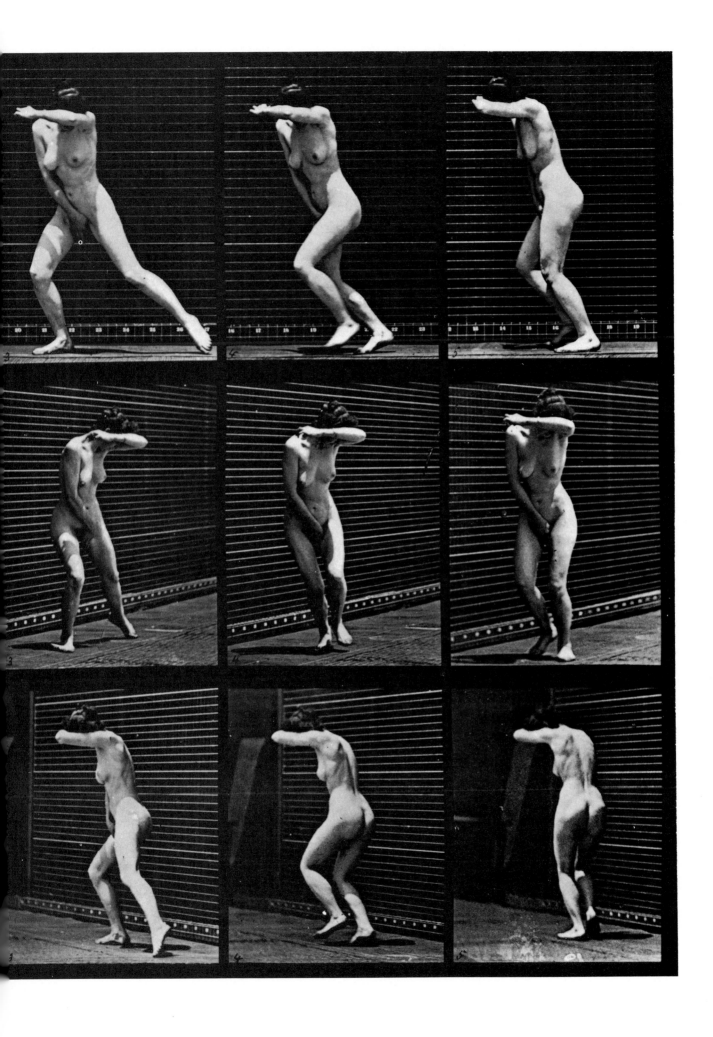

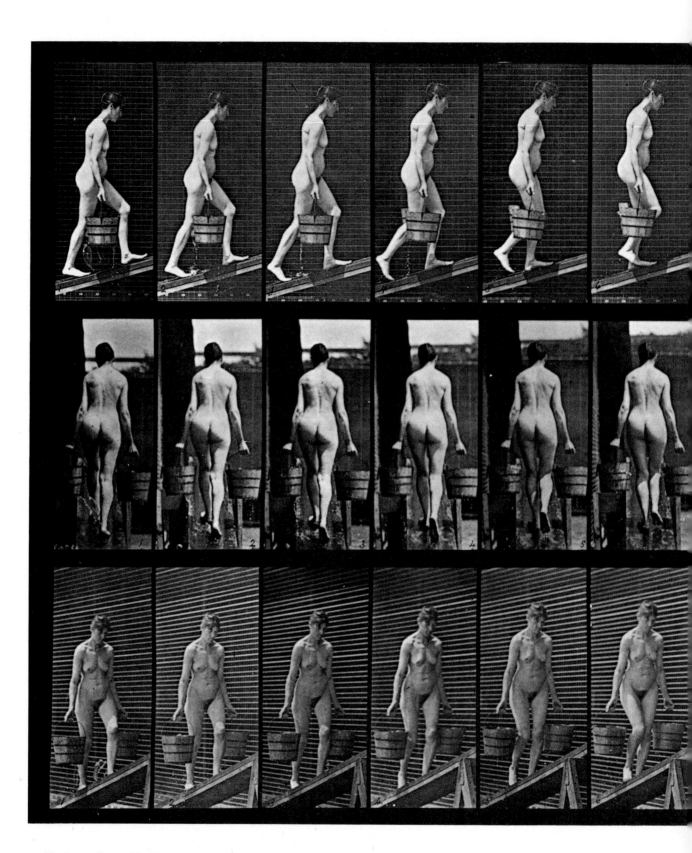

35. *Ascending an incline with a bucket of water in each hand.*

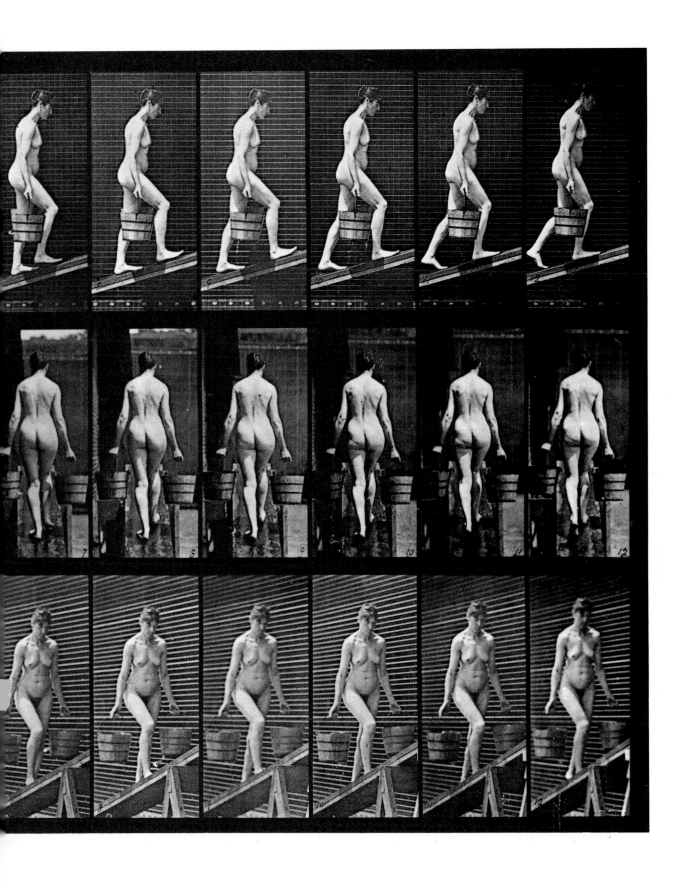

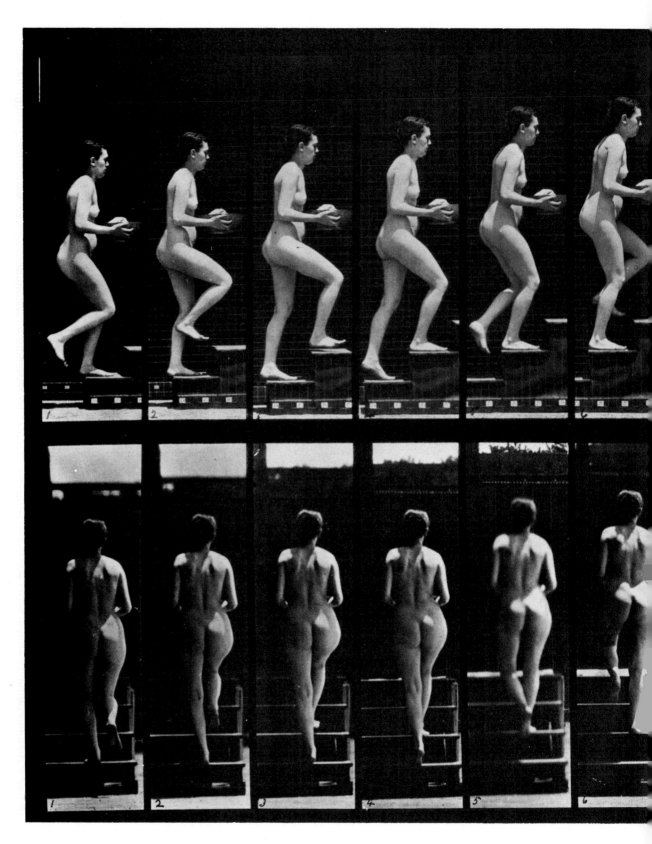

36. *Ascending stairs and looking around with basin in hands.*

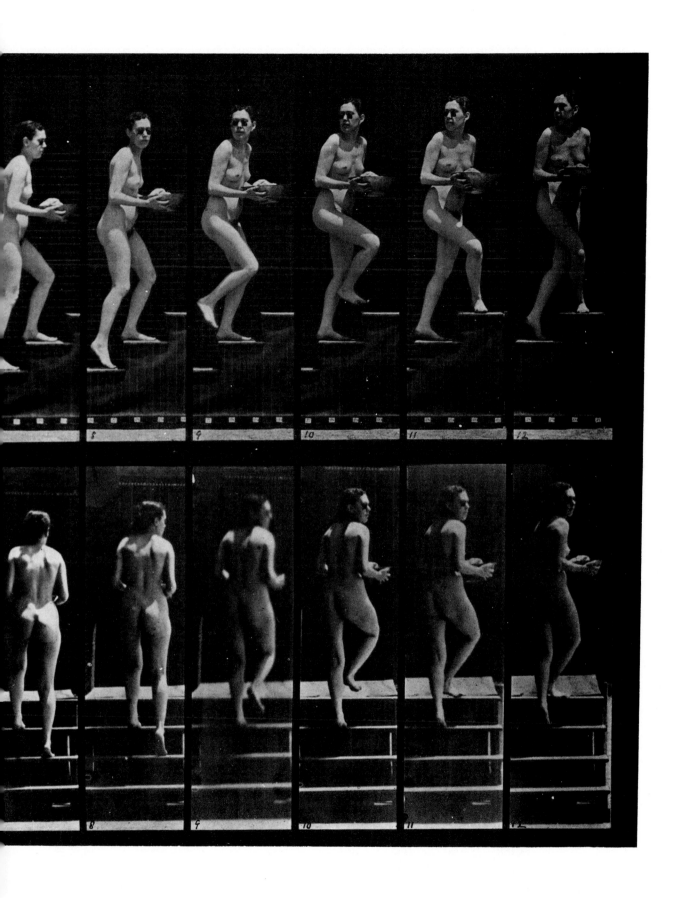

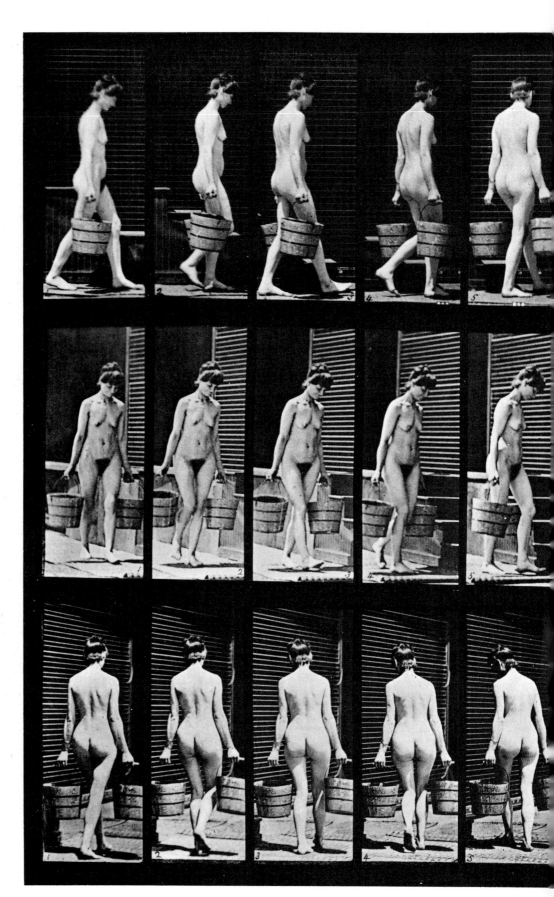

37. *Turning and ascending stairs with a bucket of water in each hand.*

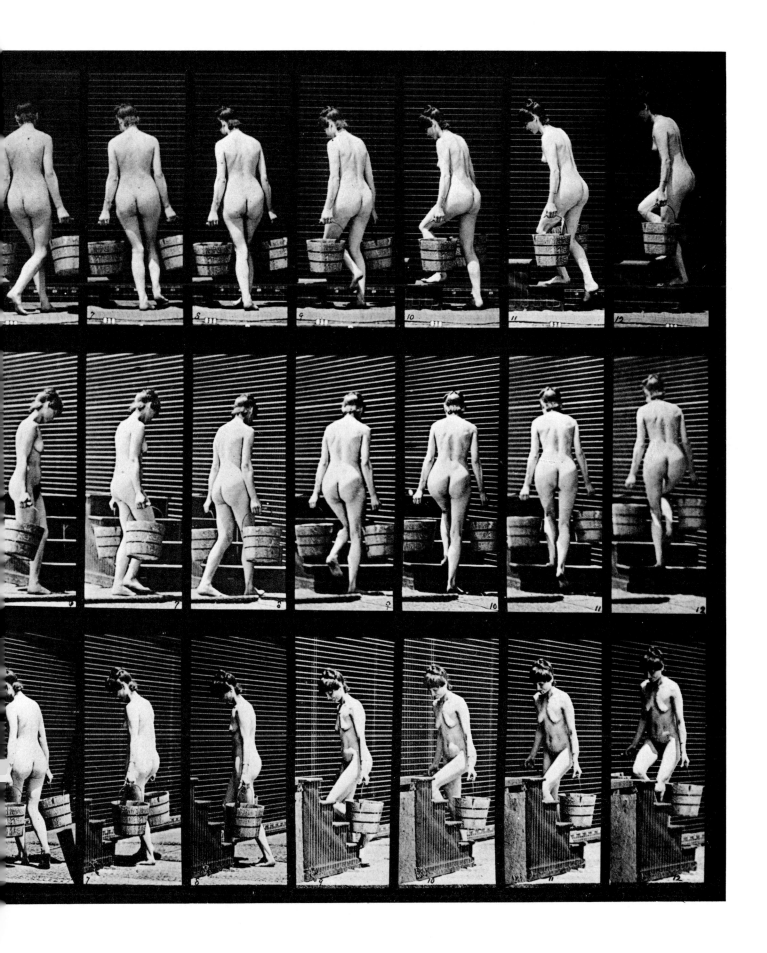

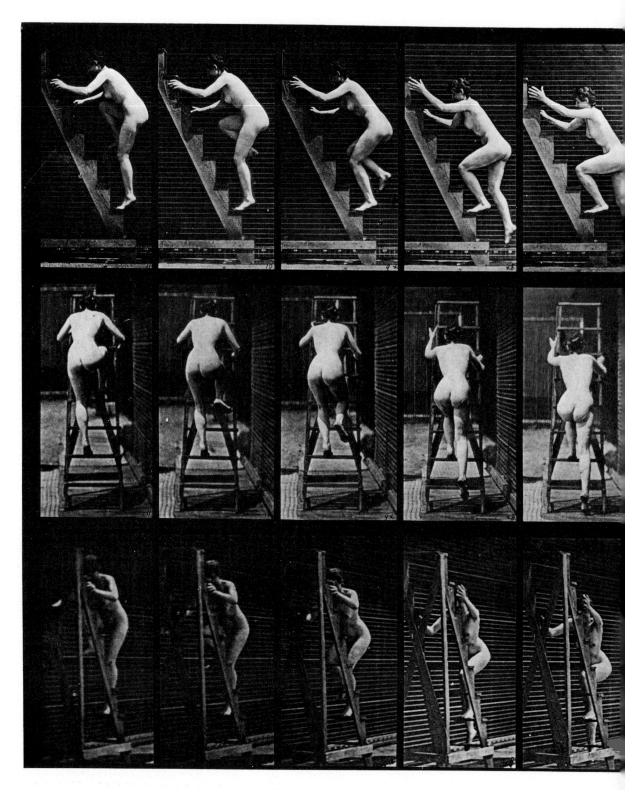

38. Ascending a stepladder two steps at a time.

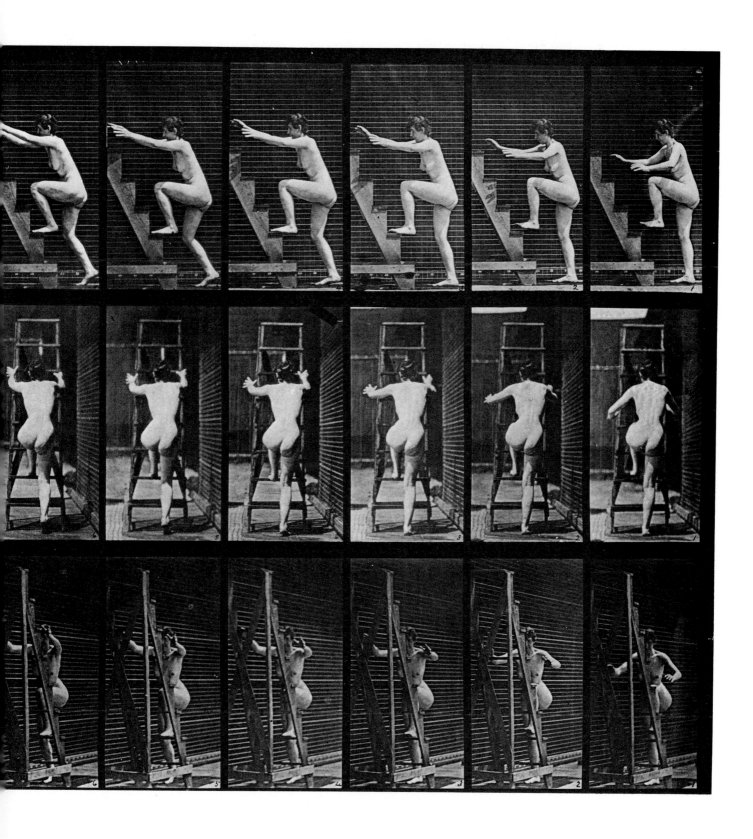

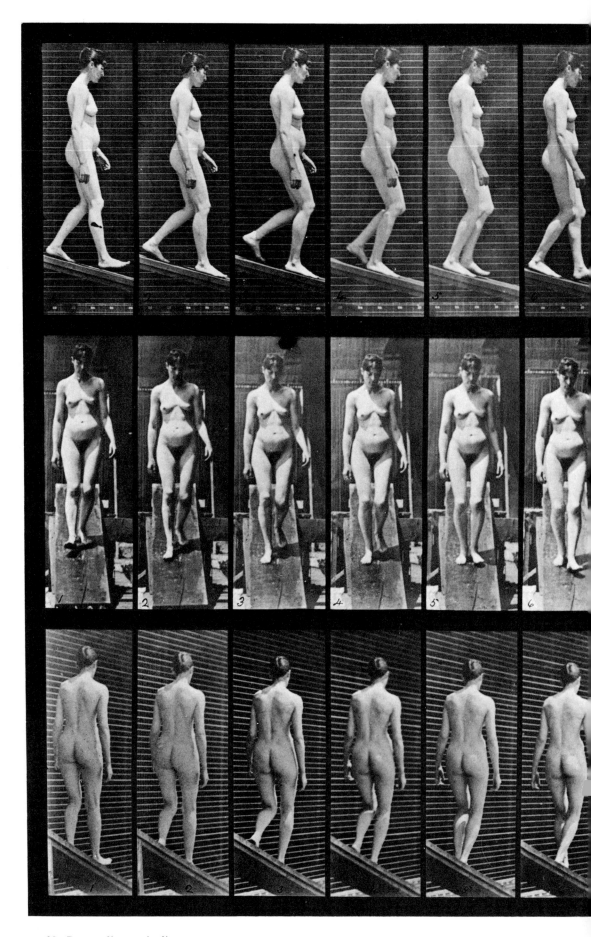

39. *Descending an incline.*

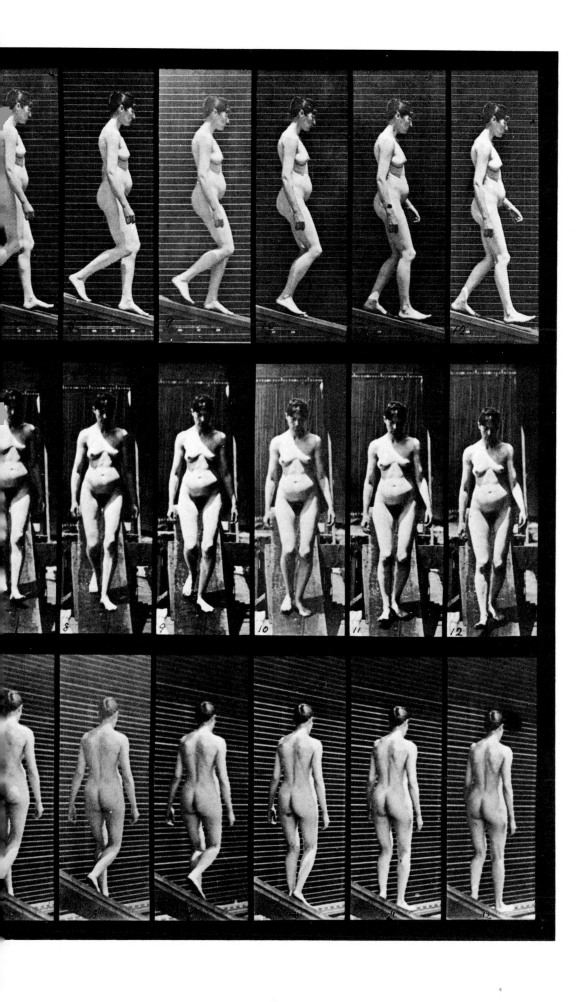

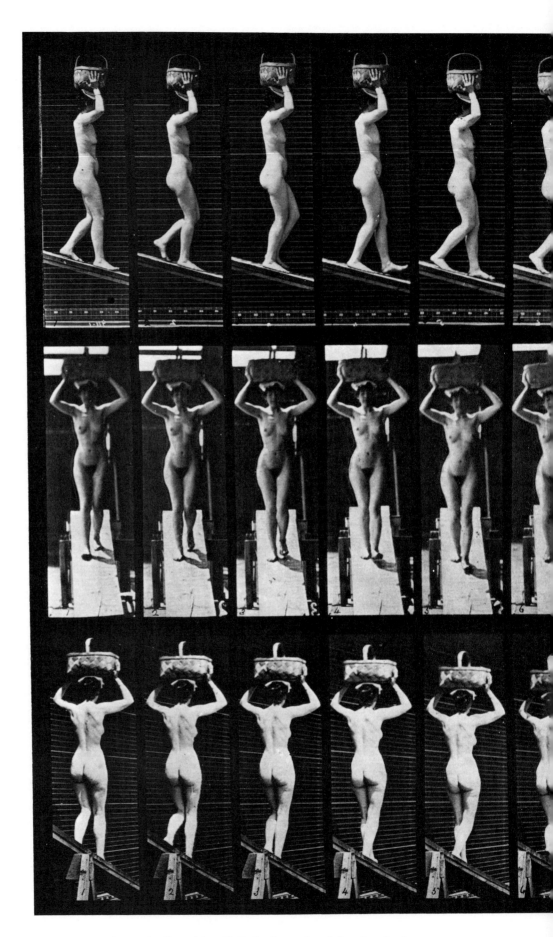

40. *Descending an incline with a 20-lb. basket on head, hands raised.*

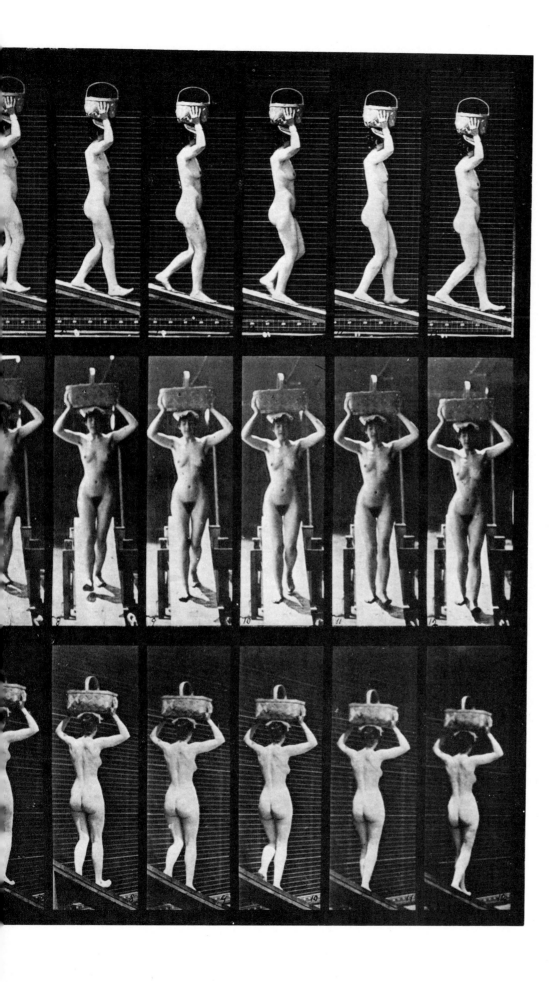

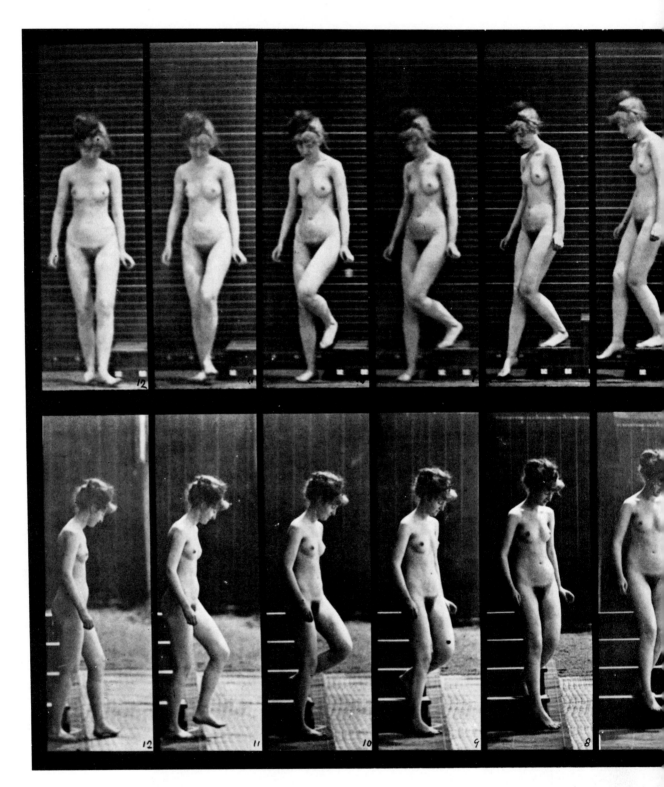

41. *Descending stairs and turning around.*

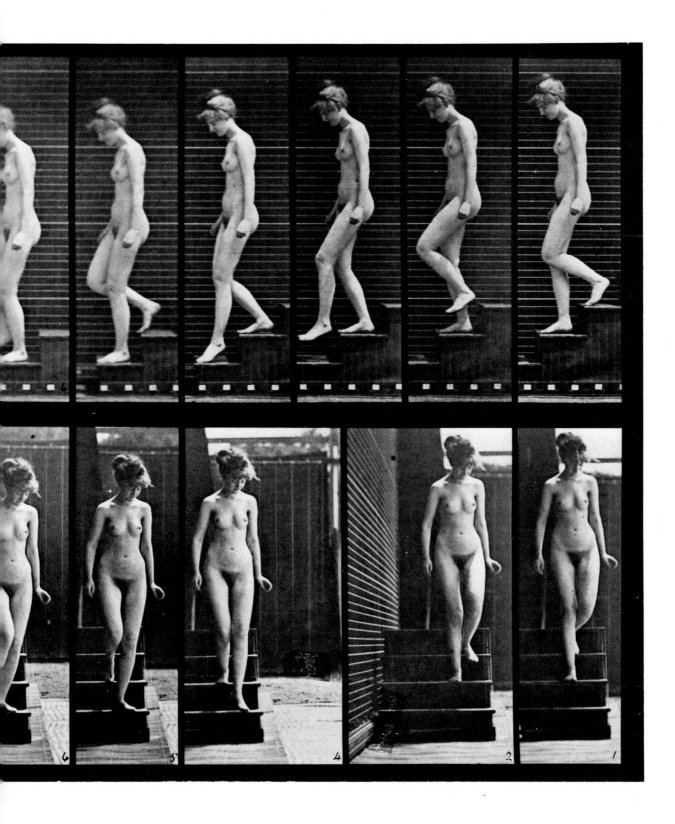

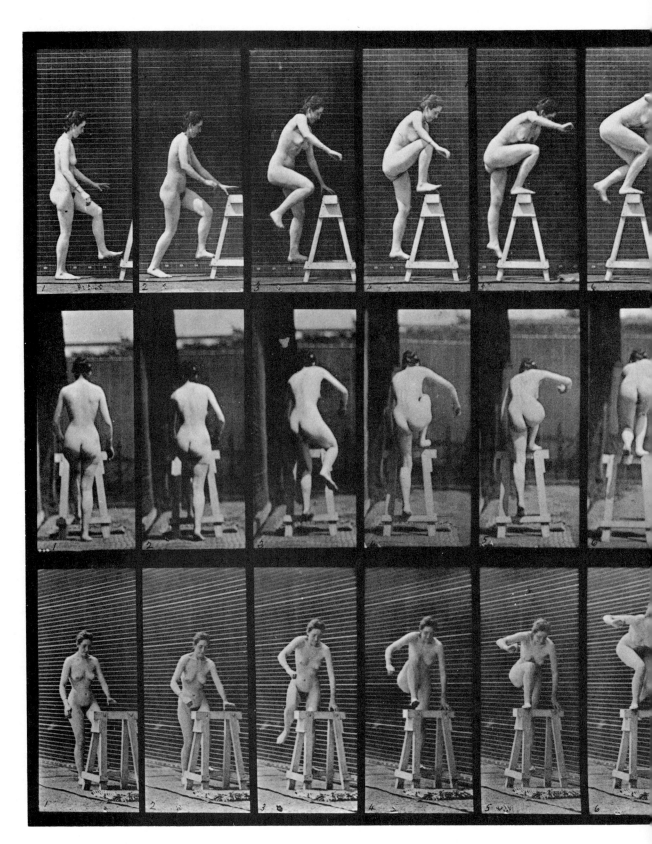

42. *Stepping up on a trestle, jumping down and turning.*

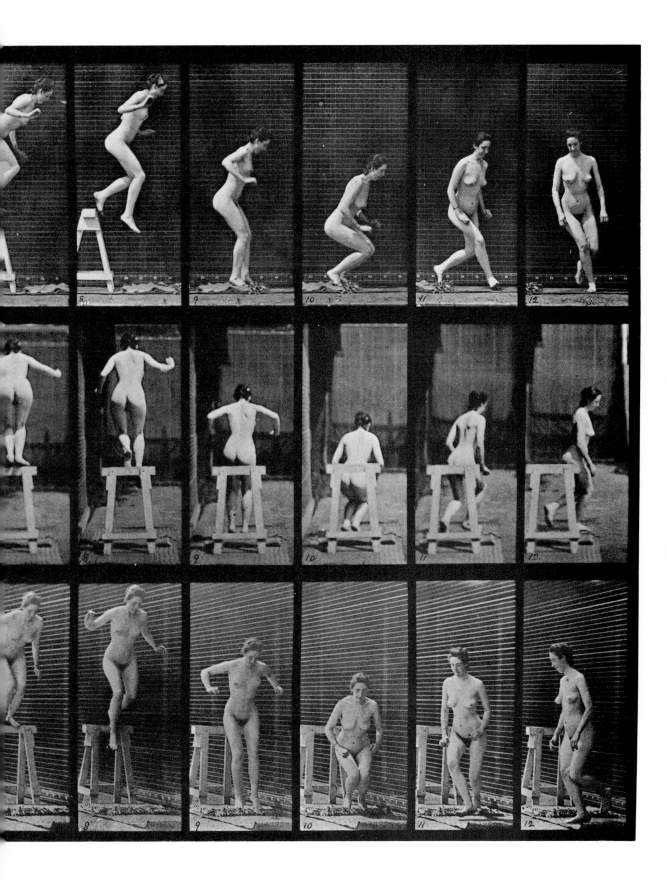

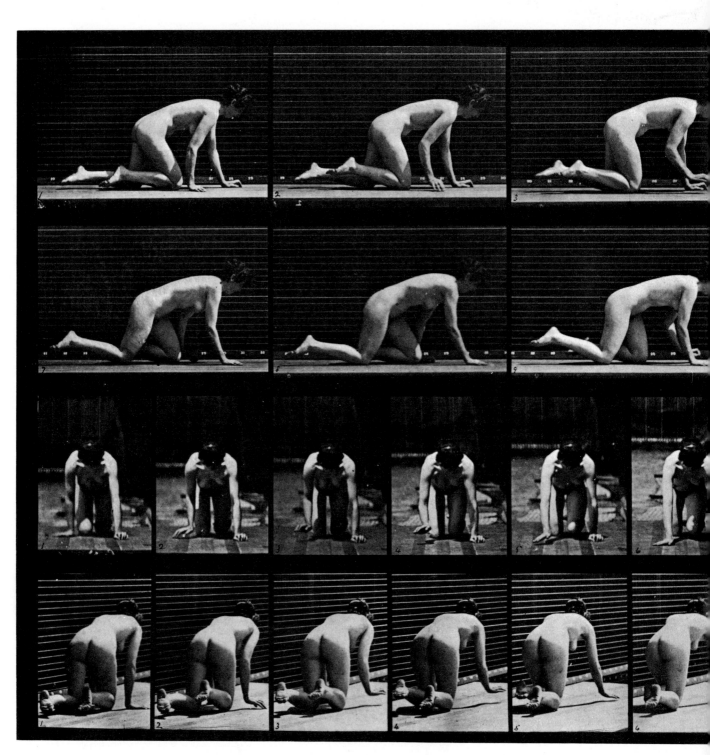

43. *Crawling on hands and knees.*

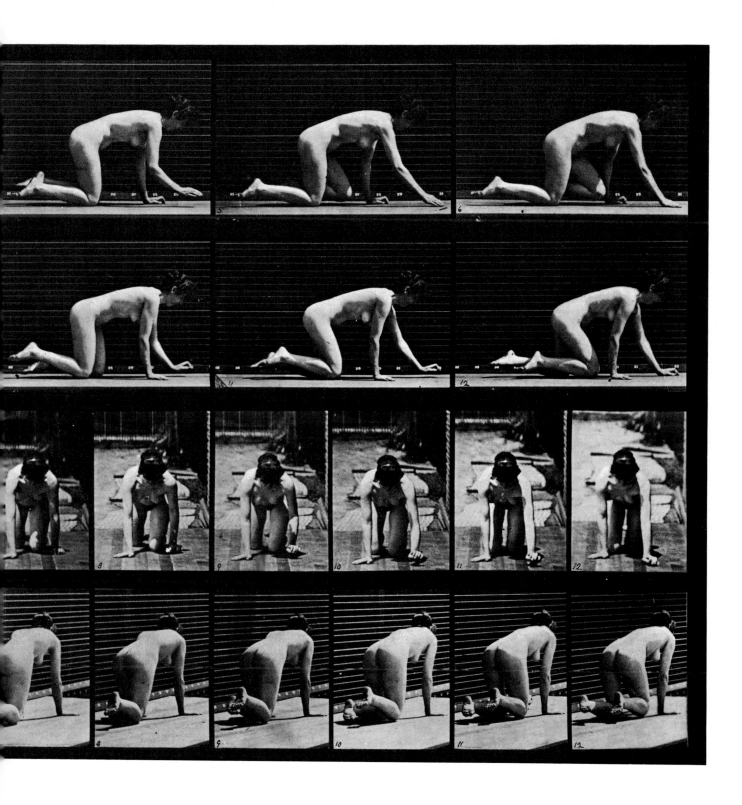

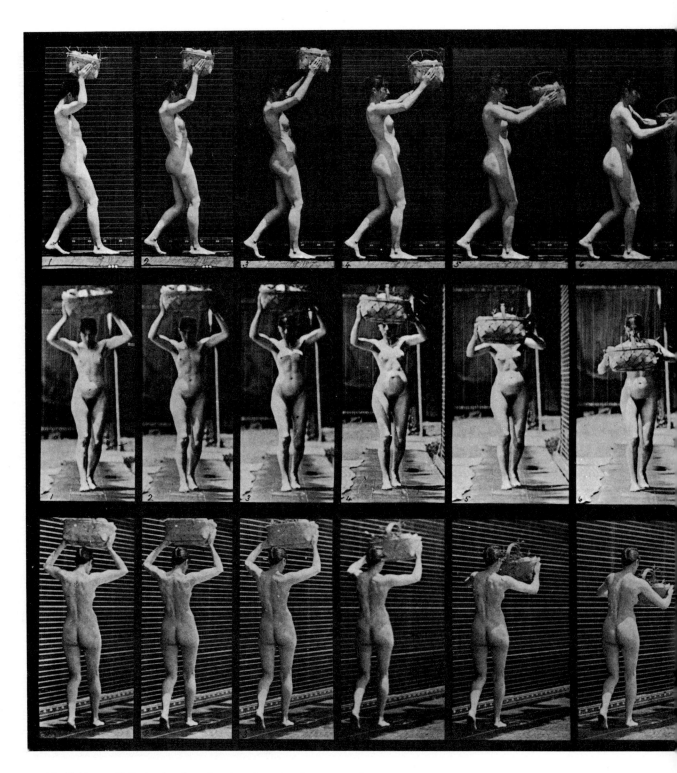

44. Taking a 12-lb. basket from head and putting it on ground.

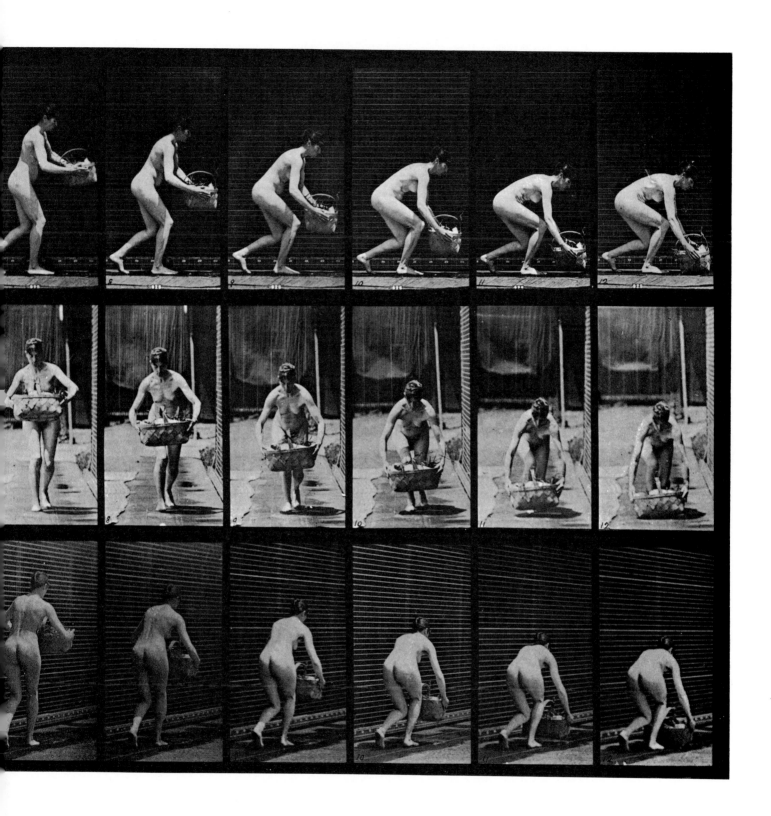

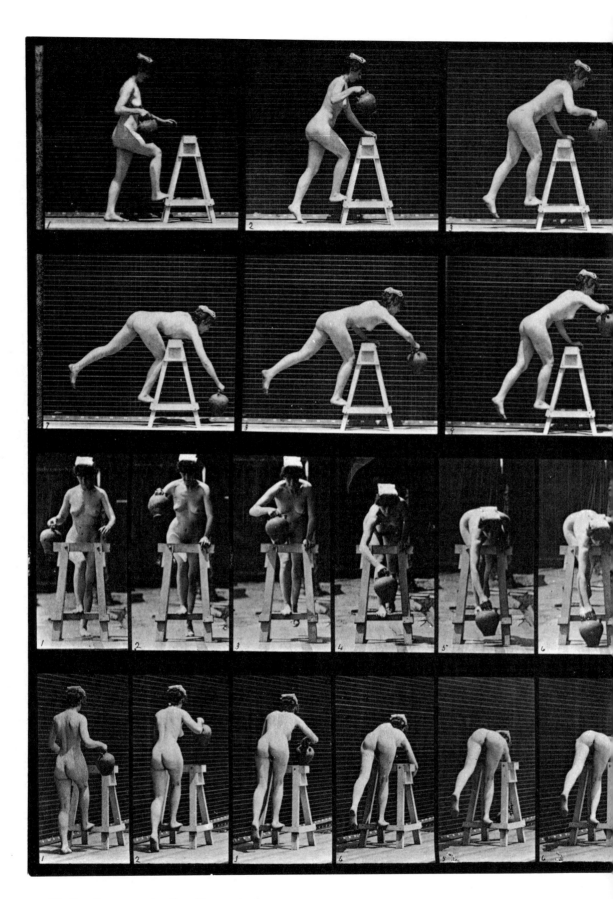

45. *Bending over a trestle with a water jar.*

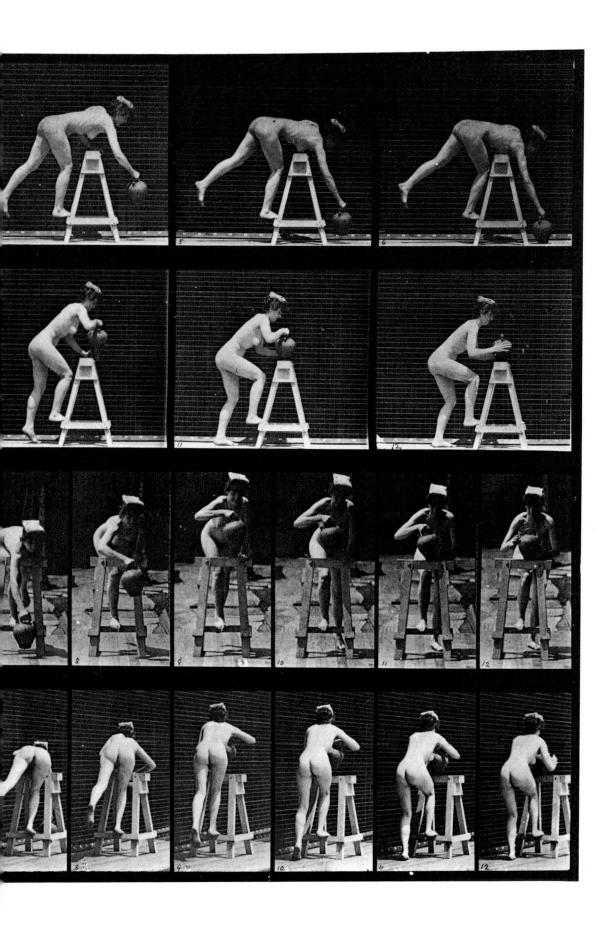

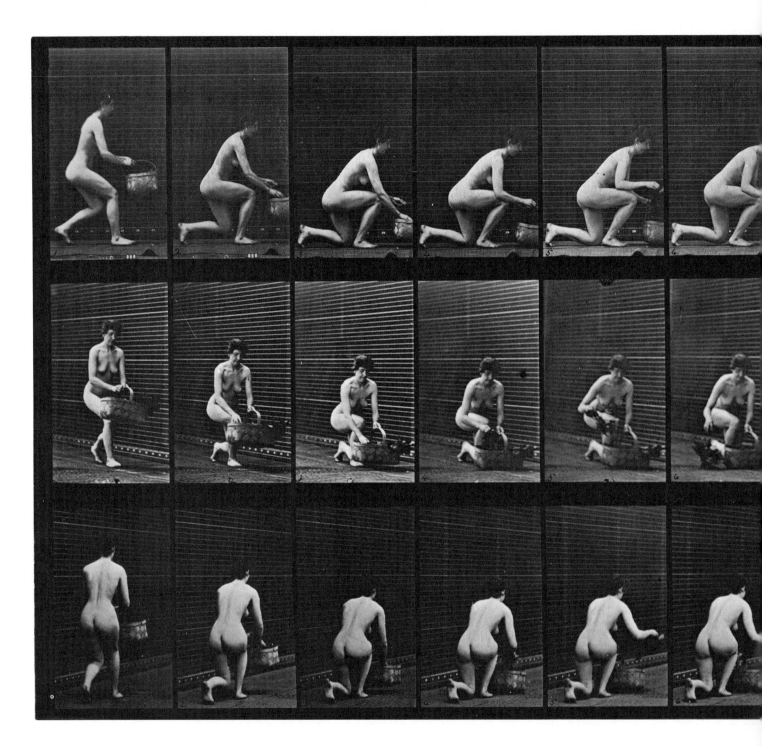

46. *Kneeling on left knee, carrying basket, and rising.*

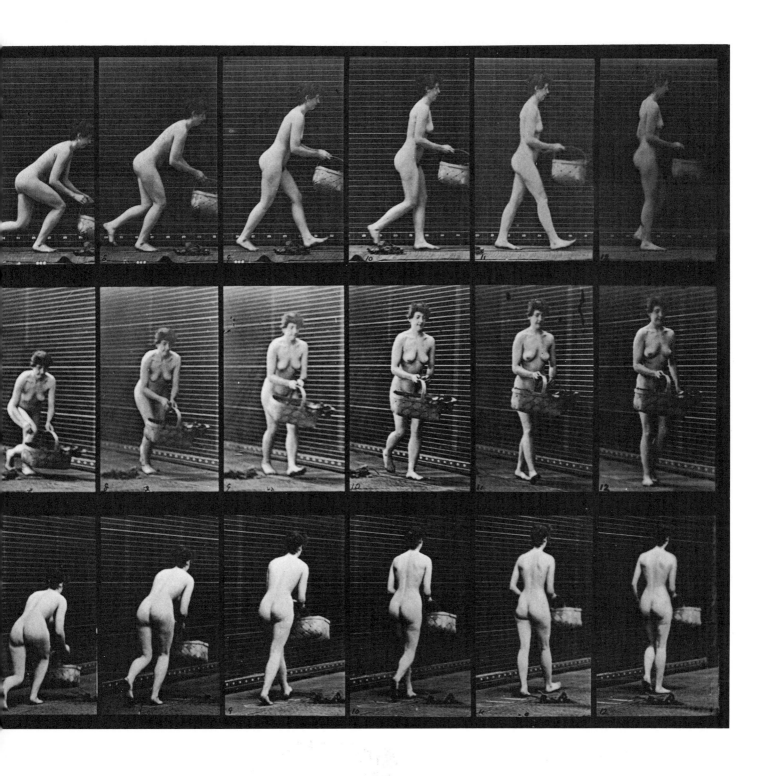

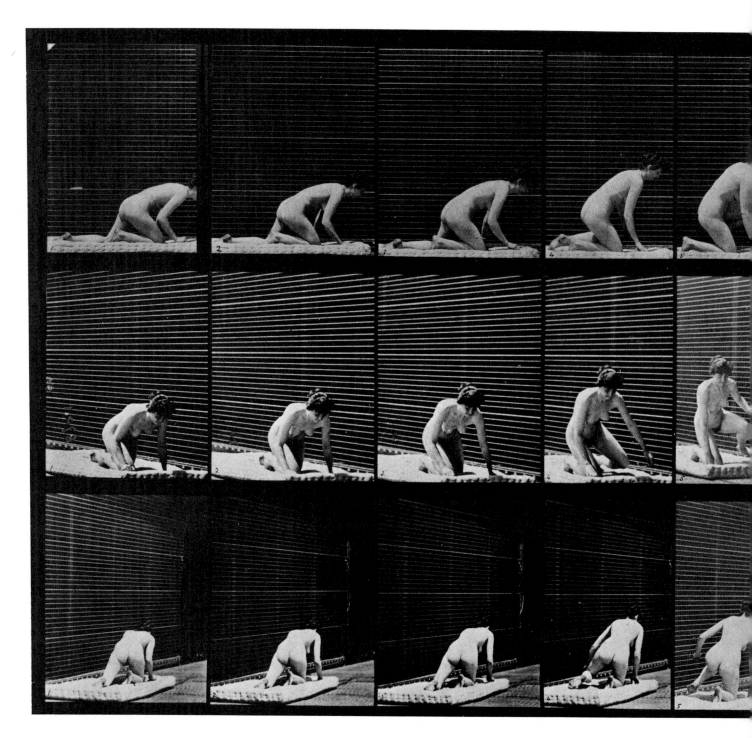

47. *Arising from kneeling and turning.*

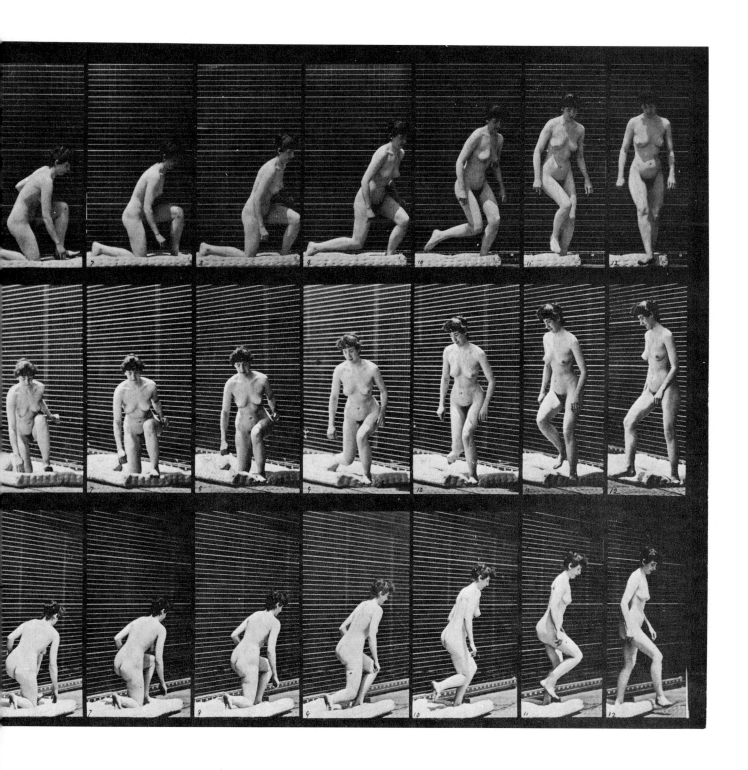

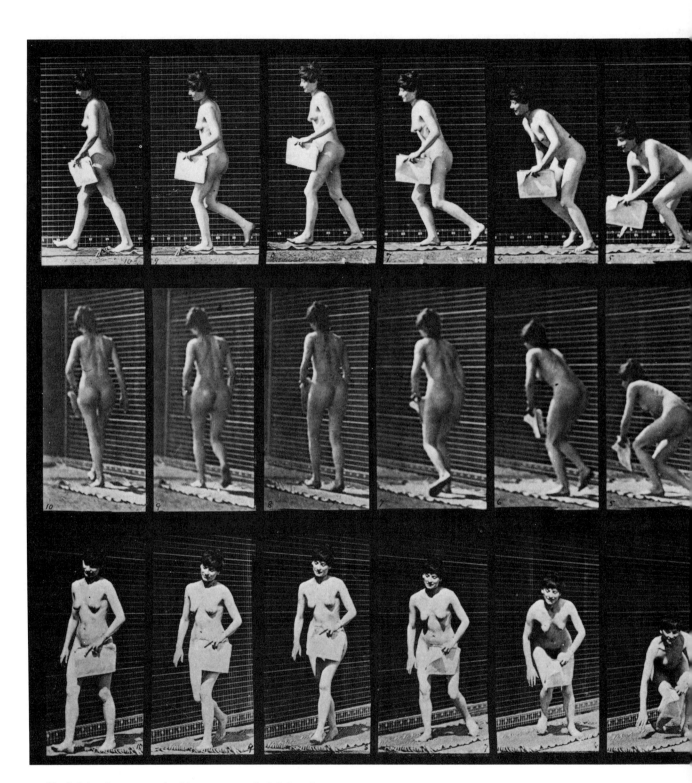

48. *Arising from ground with newspaper in left hand.*

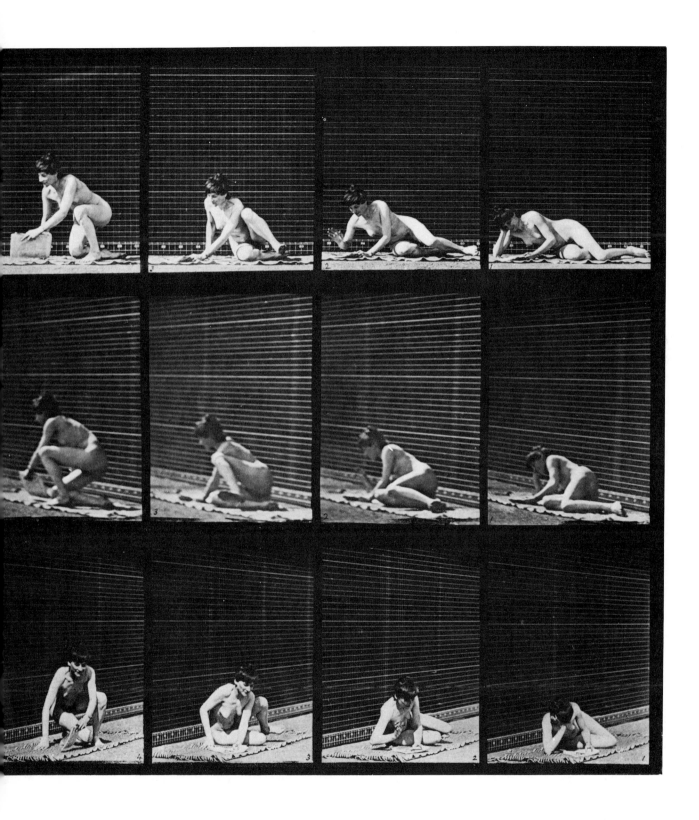

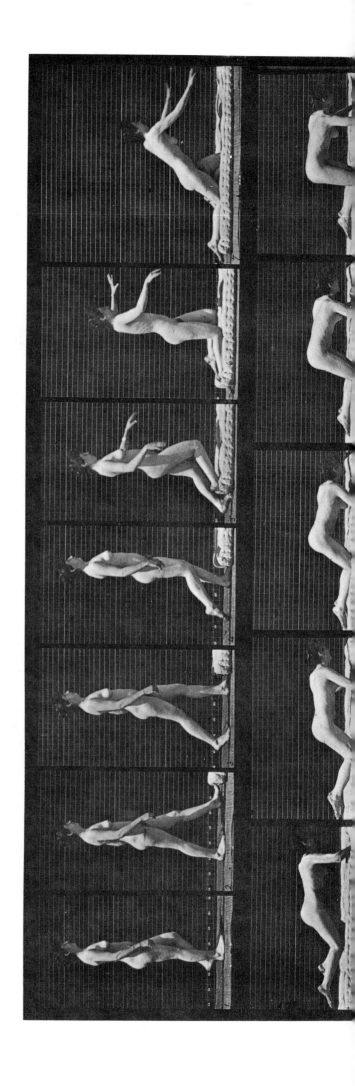

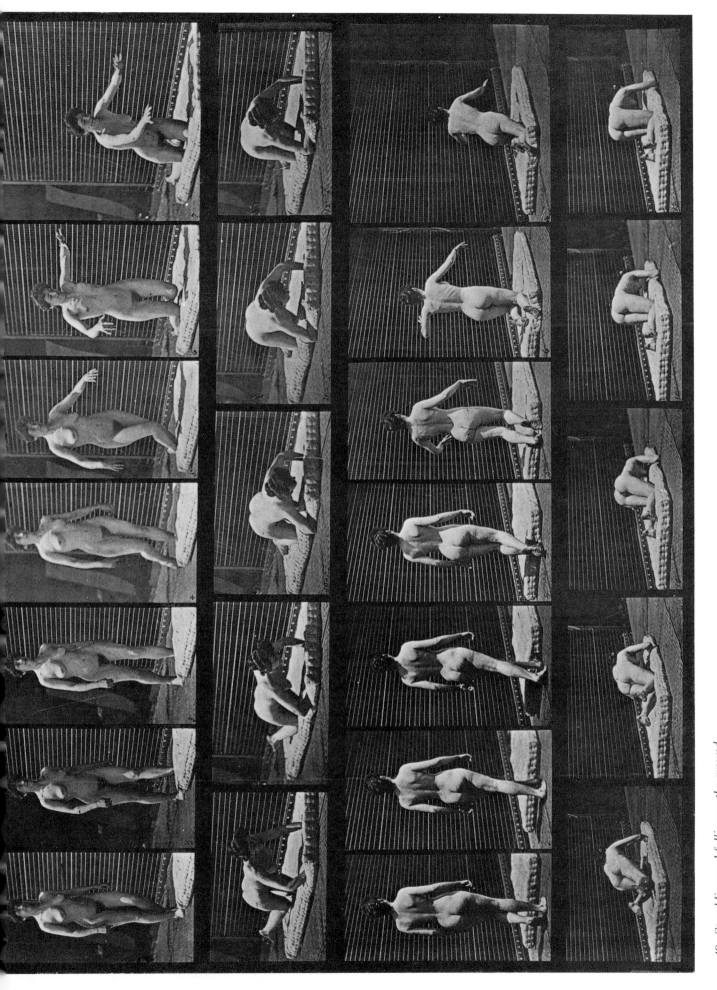

49. *Stumbling and falling on the ground.*

99

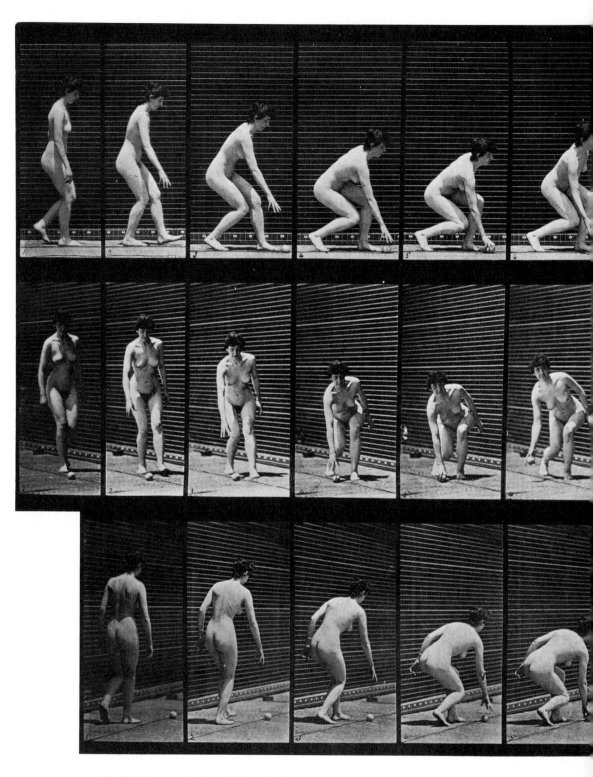

50. *Picking up a ball and throwing it.*

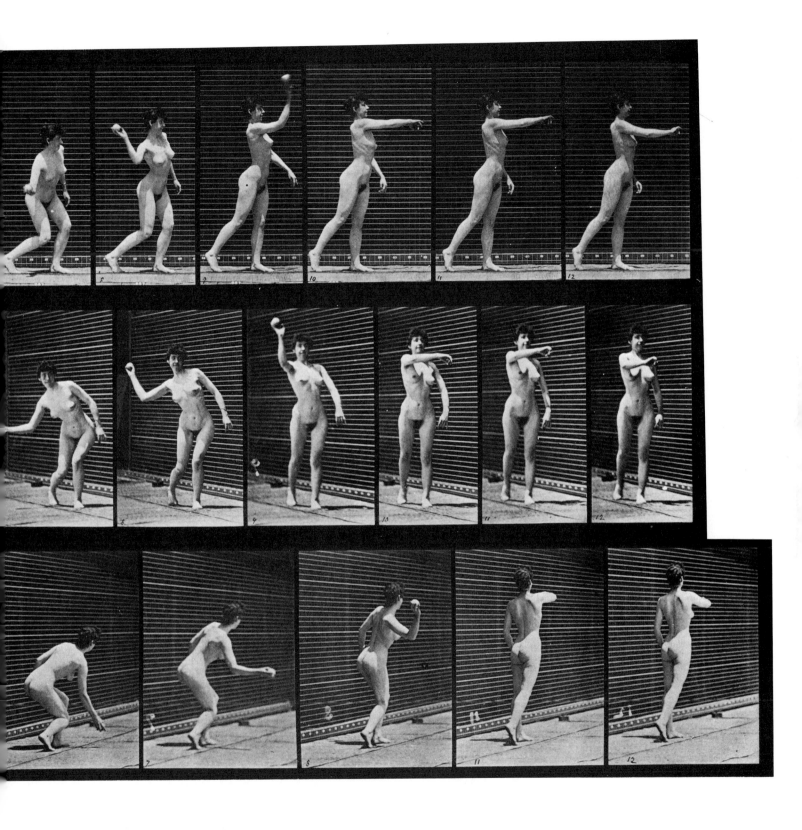

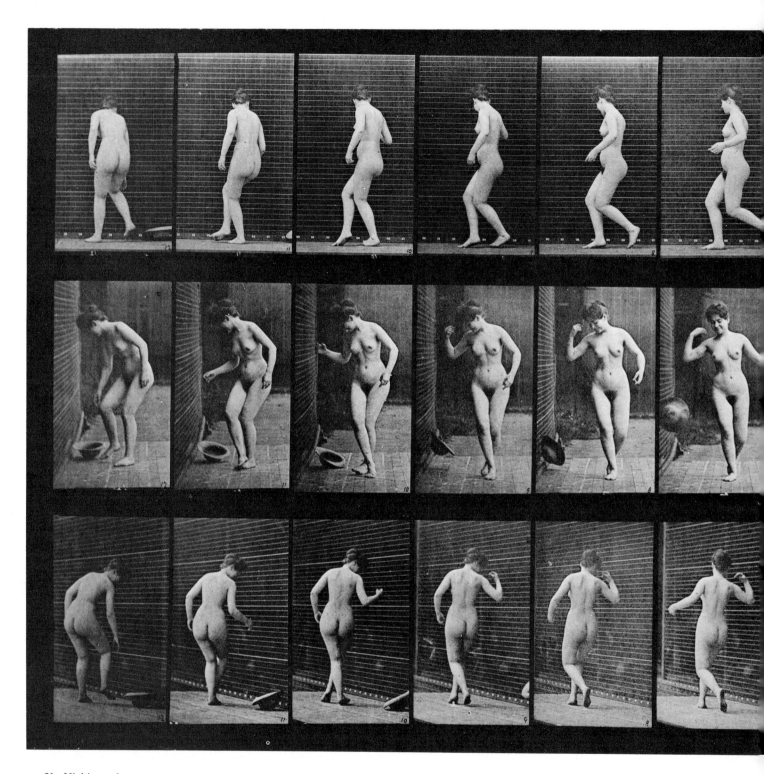

51. *Kicking a hat.*

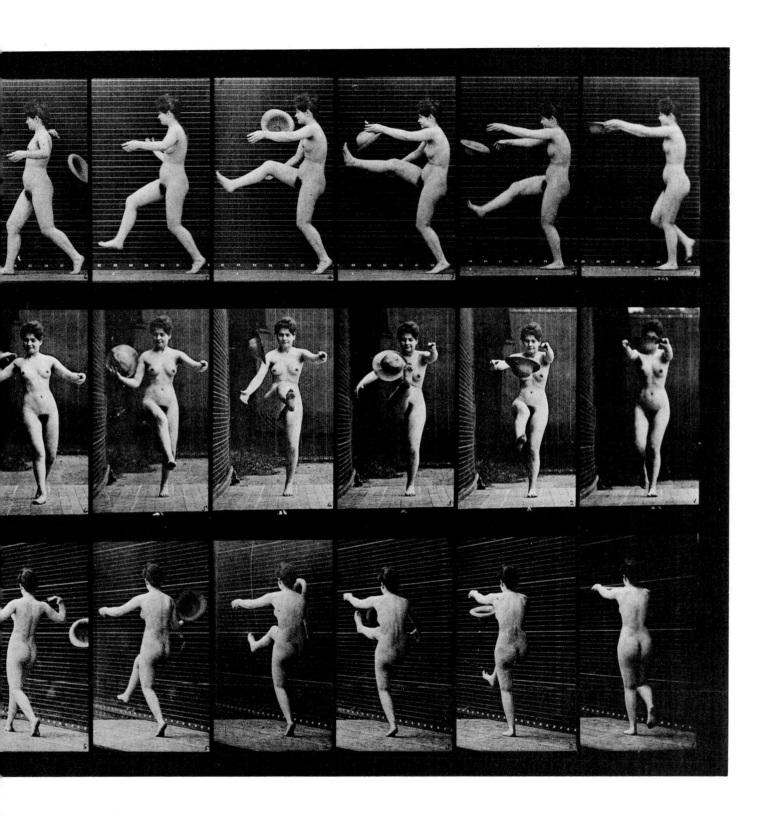

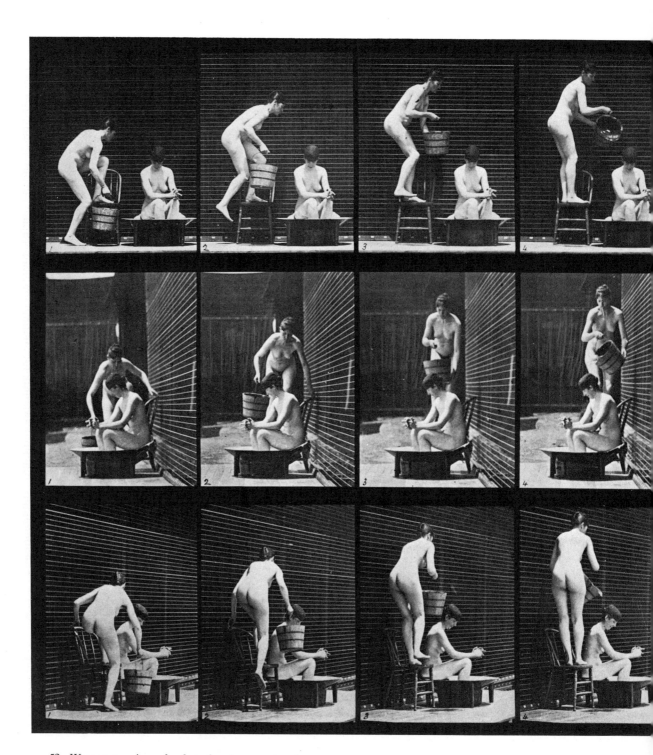

52. *Woman pouring a bucket of water over another woman.*

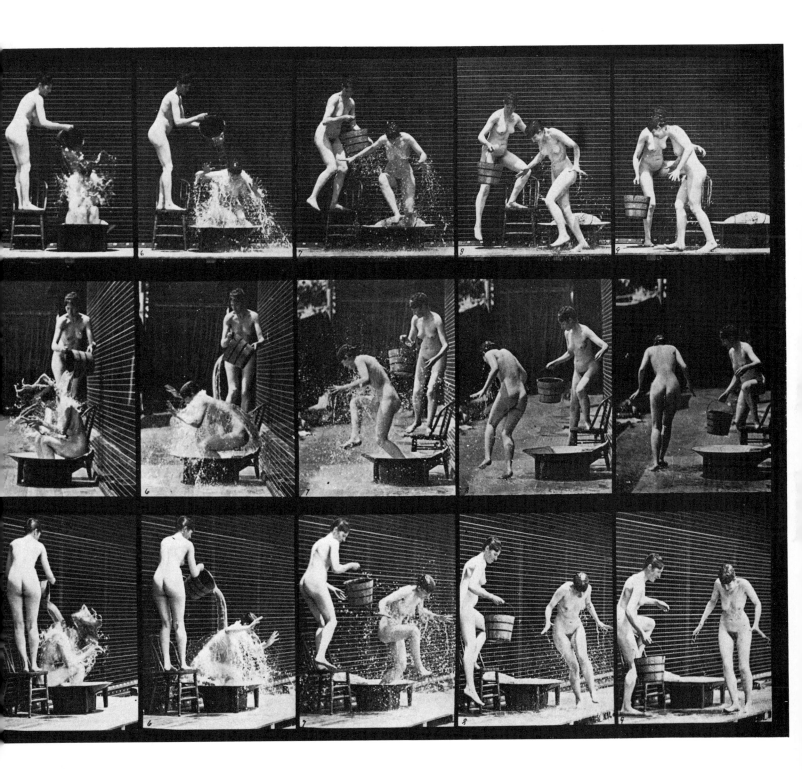

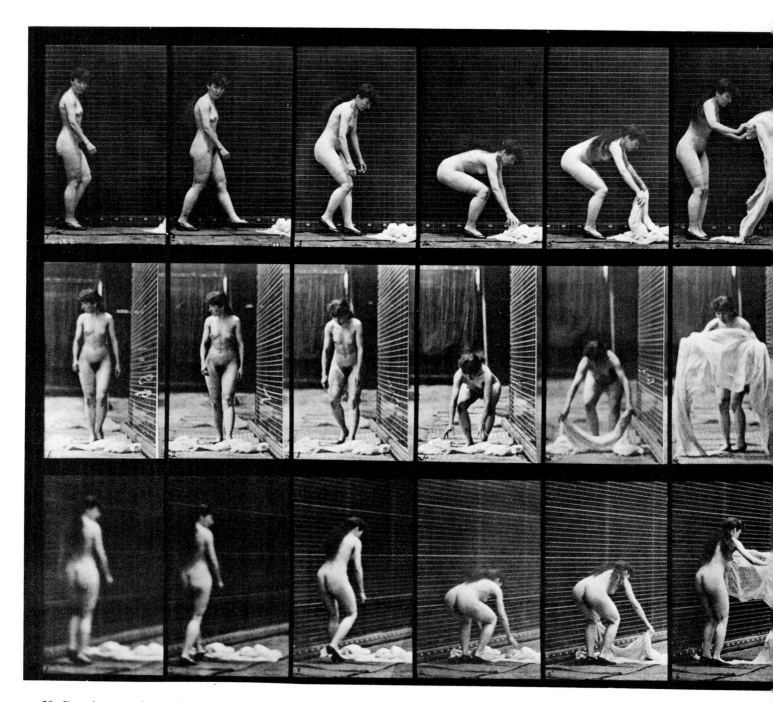

53. Dressing: stooping and throwing wrap around shoulders.

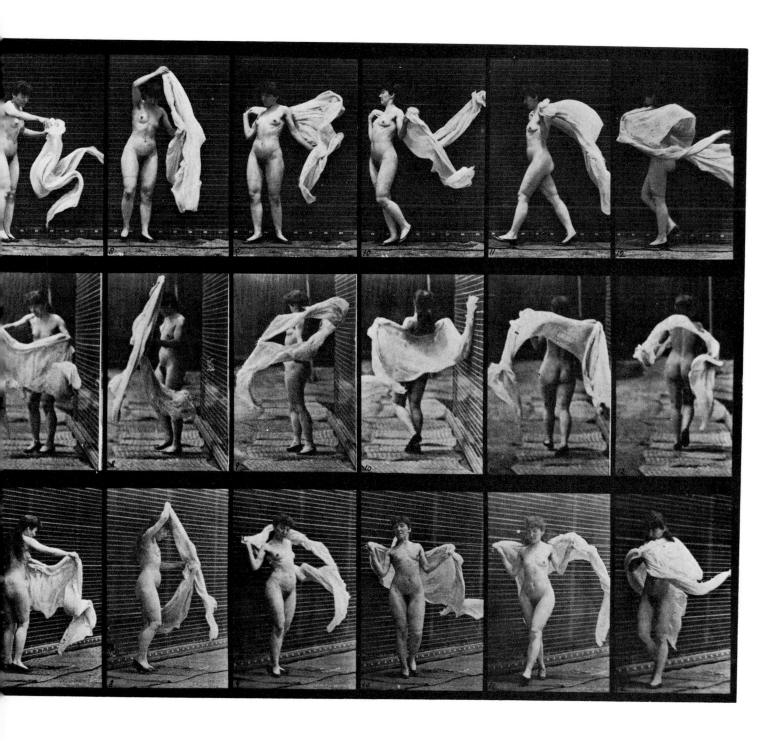

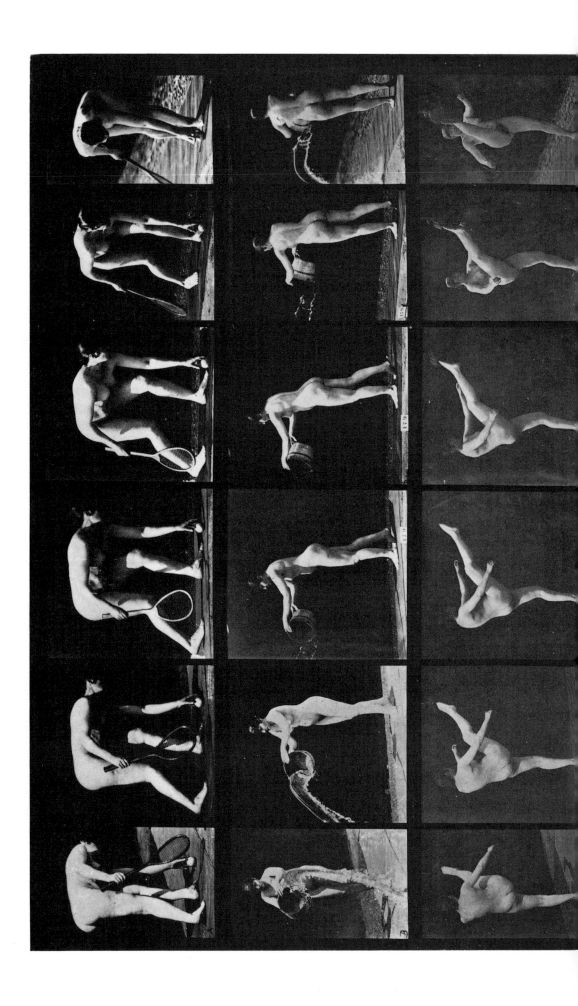

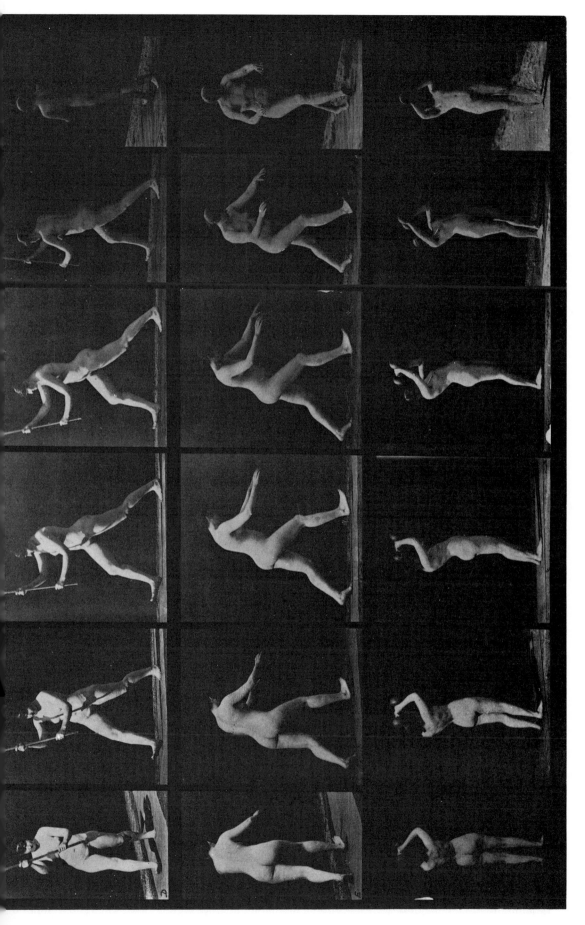

54. A: Lifting a ball. B: Emptying a bucket of water. C: Kicking above her head.
D: Striking with a stick. E: Stumbling. F: Lifting a 50-lb. dumbbell.

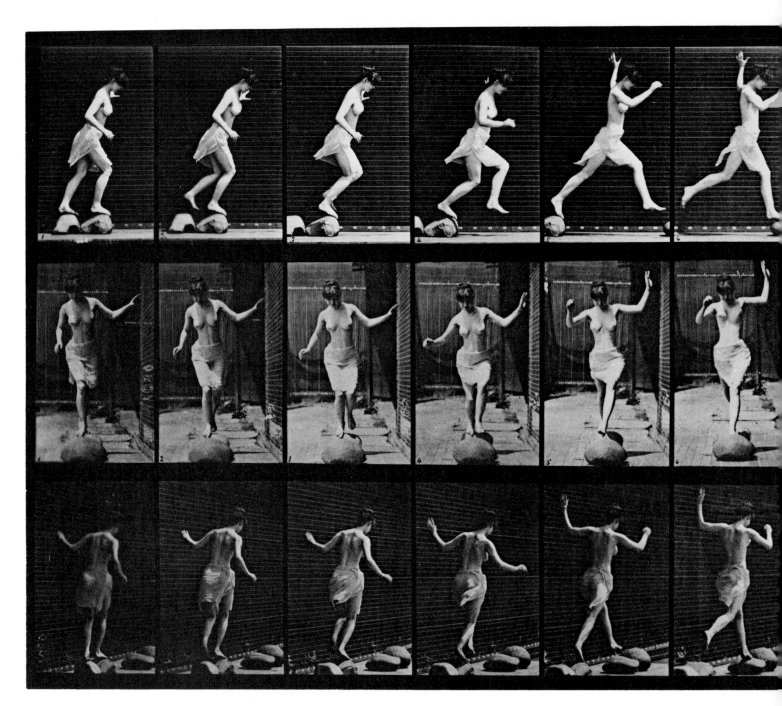

55. *Jumping from stone to stone across a brook.*

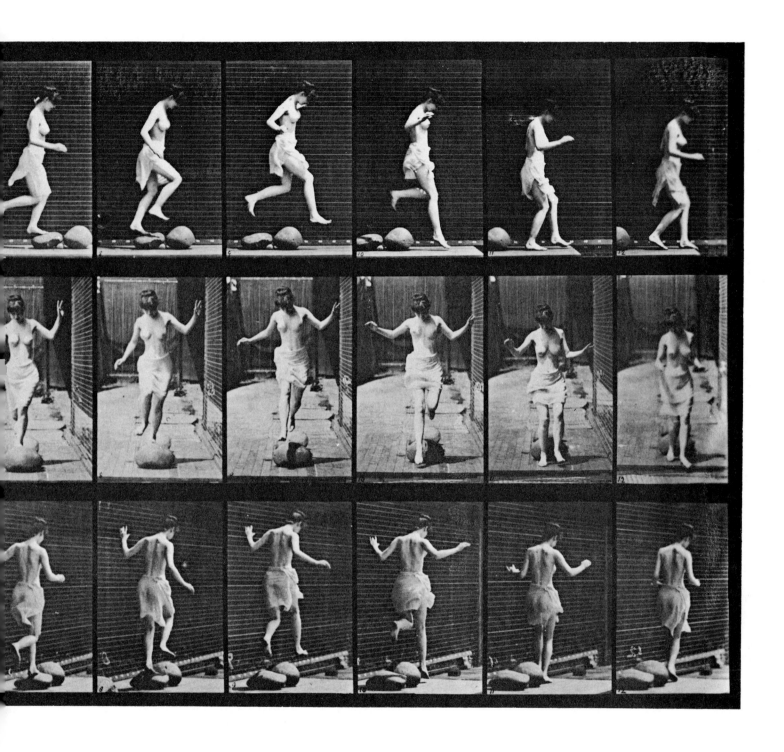

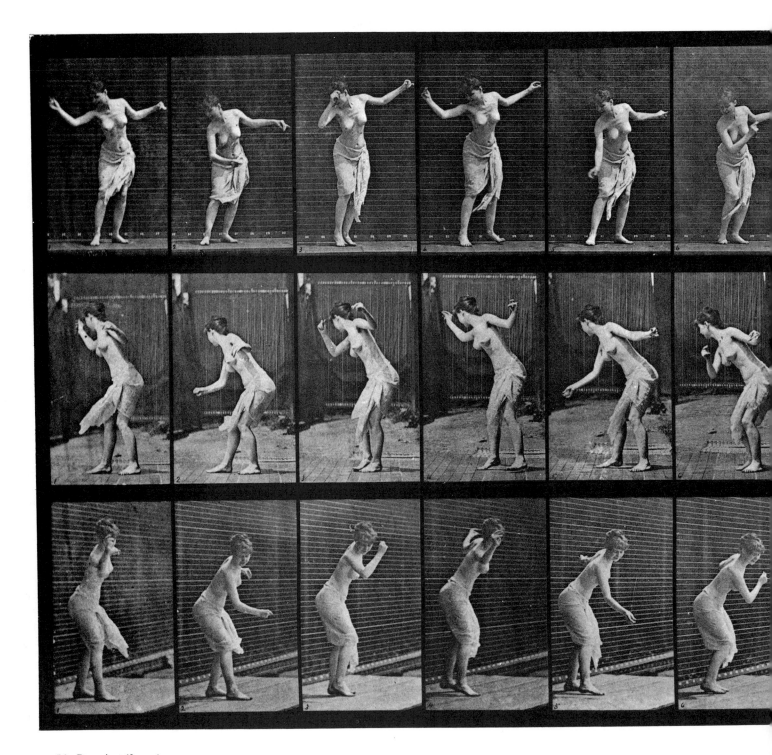

56. Dancing (fancy).

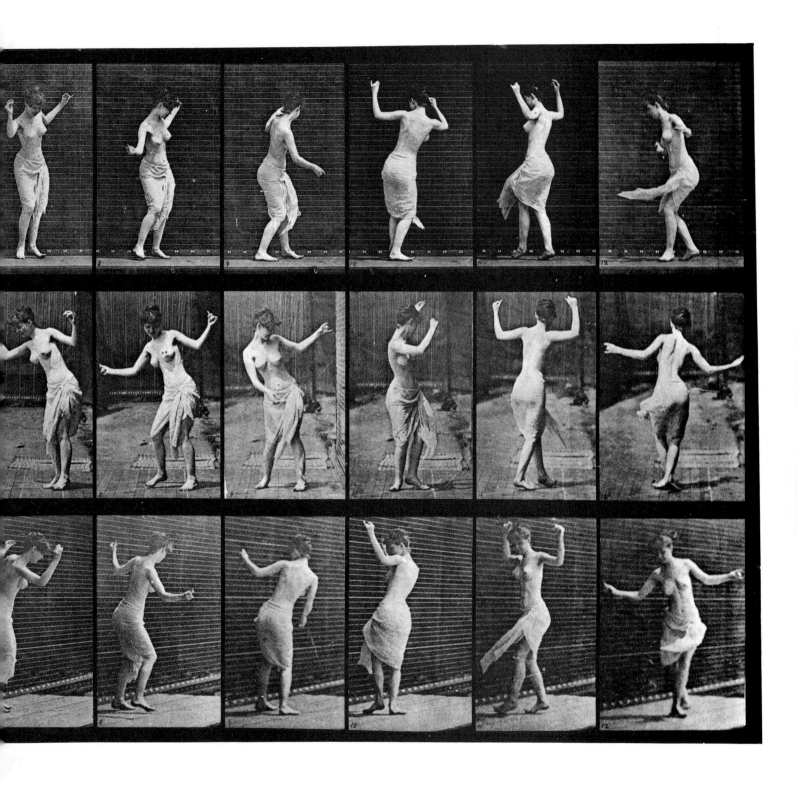

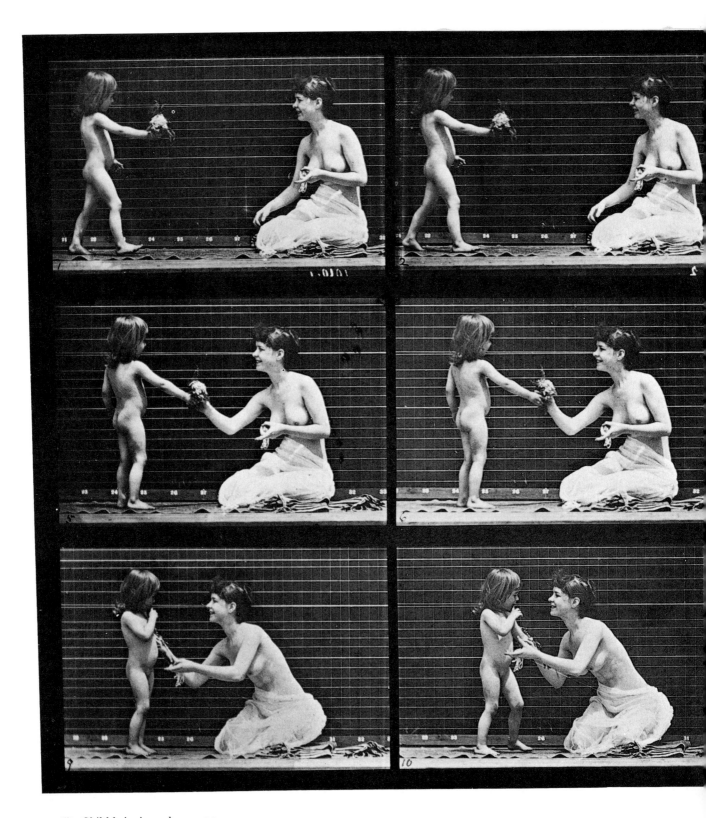

57. *Child bringing a bouquet to a woman.*

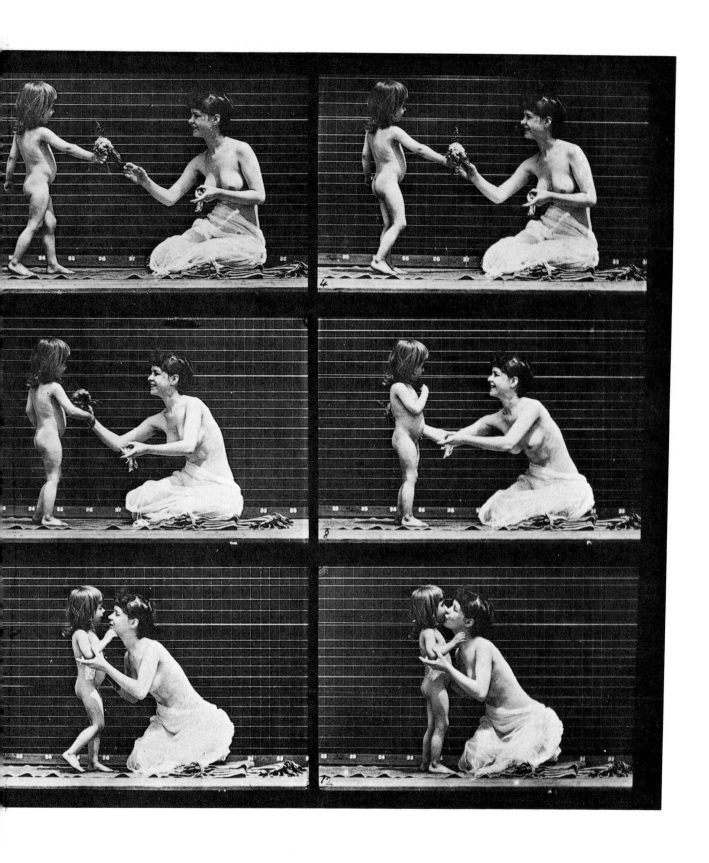

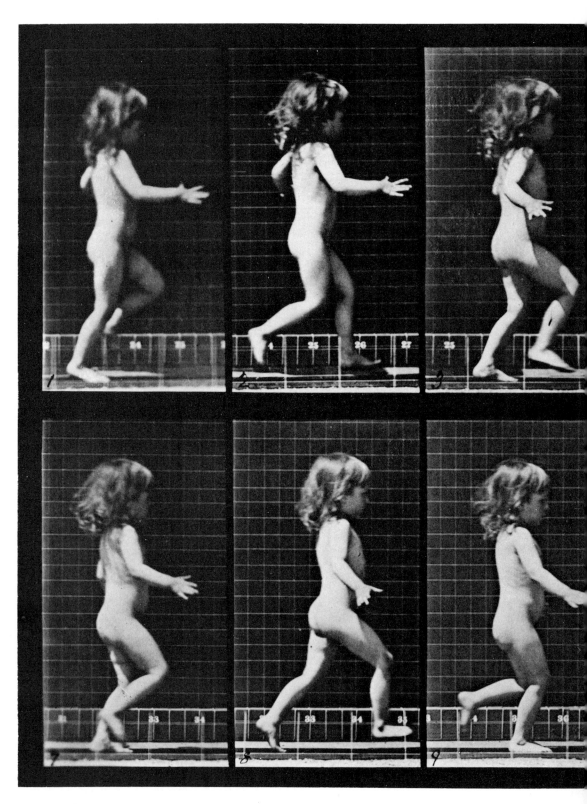

58. Child running.

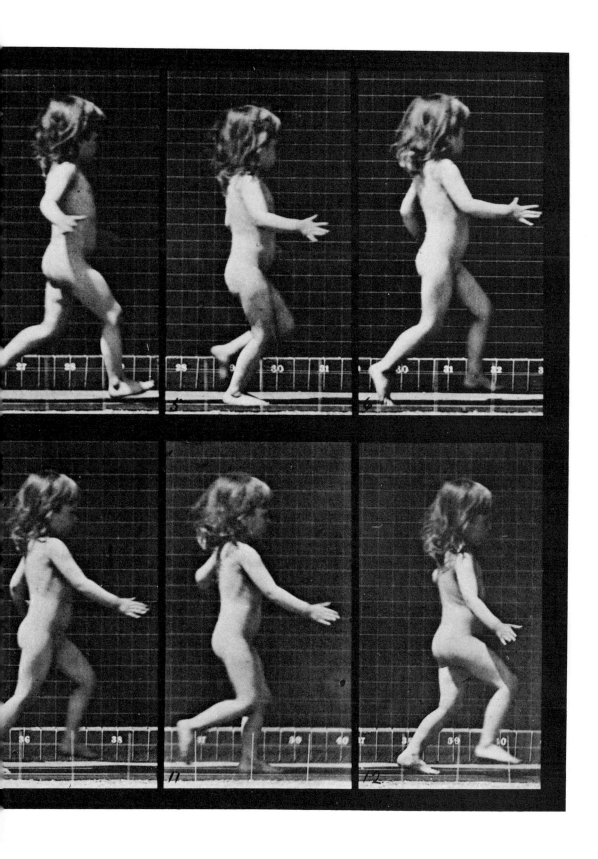

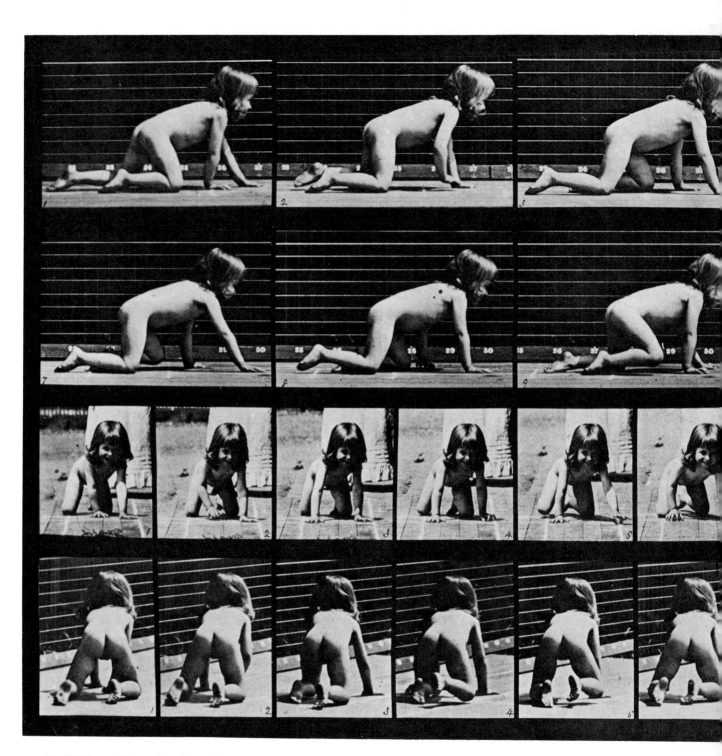

59. *Child crawling on hands and knees.*

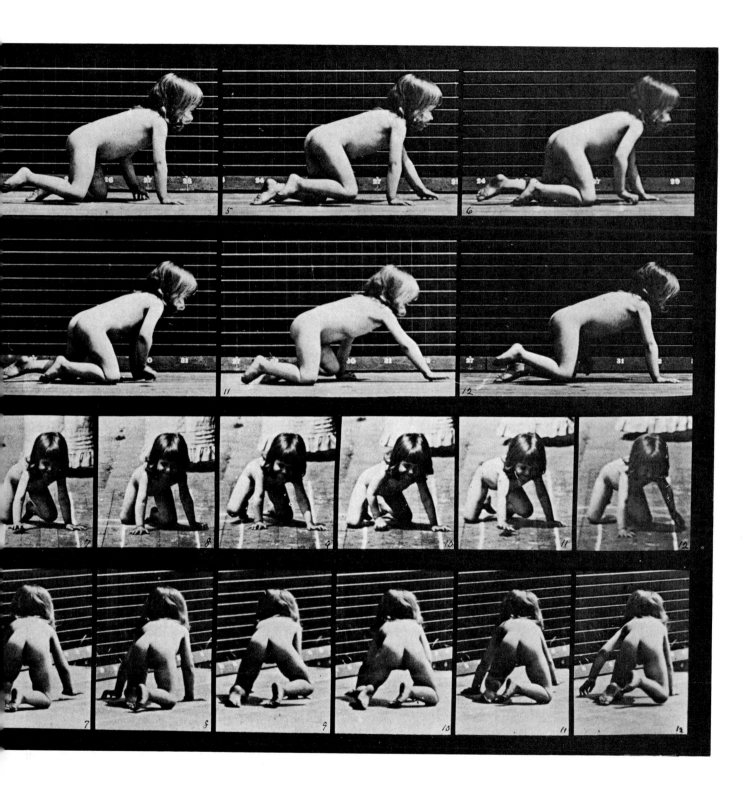

119

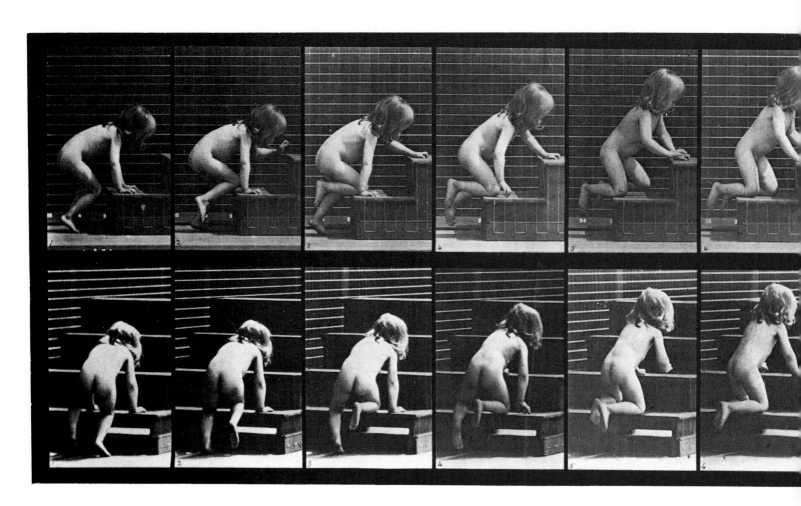

60. Child crawling up stairs.

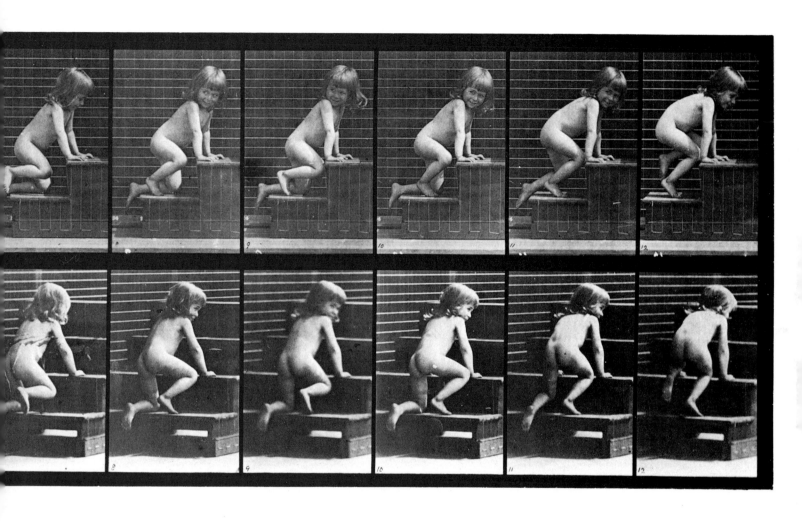